S0-ASZ-144

HAWAII

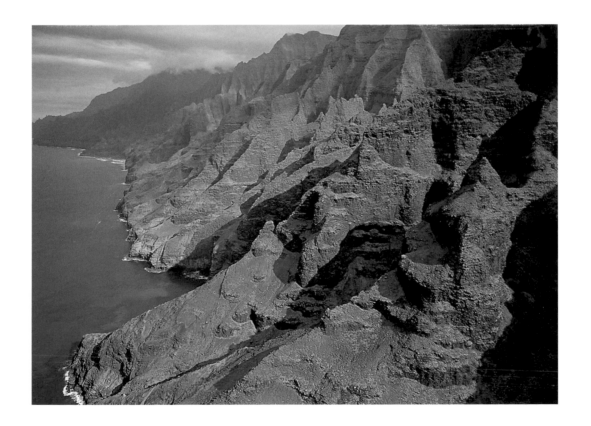

WHITECAP BOOKS

Copyright © 2002 by Whitecap Books Ltd.

All rights reserved. No part of this publication may be reproduced, stored in a
retrieval system, or transmitted in any form or by any means, electronic, mechanical,
photocopying, recording or otherwise, without prior written permission of the publisher.

The information in this book is true and complete to the best of our knowledge. All
recommendations are made without guarantee on the part of the author or Whitecap
Books Ltd. The author and publisher disclaim any liability in connection with the use
of this information. For additional information please contact Whitecap Books Ltd.,
351 Lynn Avenue, North Vancouver, British Columbia, Canada, V7J 2C4.

Text by Tanya Lloyd Kyi
Edited by Elaine Jones
Photo editing by Tanya Lloyd Kyi
Proofread by Lisa Collins
Cover layout by Jacqui Thomas
Interior layout by Jane Lightle

Printed and bound in Canada

National Library of Canada Cataloguing in Publication Data
Kyi, Tanya Lloyd, 1973–
 Hawaii

 (America series)
 ISBN 1-55285-359-4

 1. Hawaii—Pictorial works. I. Title. II. Series
DU621.5.K94 2002 996.9'042'0222 C2002-910802-0

The publisher acknowledges the support of the Canada Council and the Cultural
Services Branch of the Government of British Columbia in making this publication
possible. We acknowledge the financial support of the Government of Canada through
the Book Publishing Industry Development Program for our publishing activities.

For more information on the America Series and other Whitecap Books
titles, please visit our web site at www.whitecap.ca.

A daughter of the Earth, the volcano goddess Pele was born as a flame —beautiful, unpredictable, and possessing a violent temper. When wanderlust and family disagreements drove her from her home, Pele fled across the Pacific Ocean to the islands of Hawaii. As she discovered each island, Pele attempted to make a new home for herself, digging enormous pits in search of a place strong enough to hold her flames. At last she succeeded, settling on the Big Island of Hawaii, below the Kilauea Volcano.

Even today, Pele's spirit is restless. Her legendary home is the most active volcano in the world and when she moves, people across the Hawaiian Islands feel her tremor. Visitors following a hiking trail through a dormant crater can see steam rising from vents in the earth, reminders of eruptions from decades past. And on the Big Island, lava continues to flow down the mountainside, spewing steam as it pours into the Pacific and cools to create a new layer of land.

Hawaii encompasses eight islands, 124 islets, and countless reefs. From the time when the volcanic summits first broke the surface of the Pacific, until the ancient Polynesians arrived 1,000 years ago, the islands remained isolated. Now, more than 10,000 plants and animals are unique to the state.

In 1778, just as King Kamehameha I was uniting Hawaii under one ruler, Captain James Cook became the first European to reach the shores. Within a decade, trading began with North America and Asia. Hawaii's sandalwood trees were shipped west. Whaling and sugar production followed. By the early 1800s, the first *haoles*—white people—were living here year-round.

The new arrivals brought constant change, and the islands slowly transformed into those we know today. Although agriculture is still a major industry, tourism has taken the lead. Visitors spend more than $13 billion here each year. They come to experience the culture of the islands, to hike the rims of the volcanoes or the sea cliffs, and, most of all, to enjoy Hawaii's never-ending supply of sun and beauty.

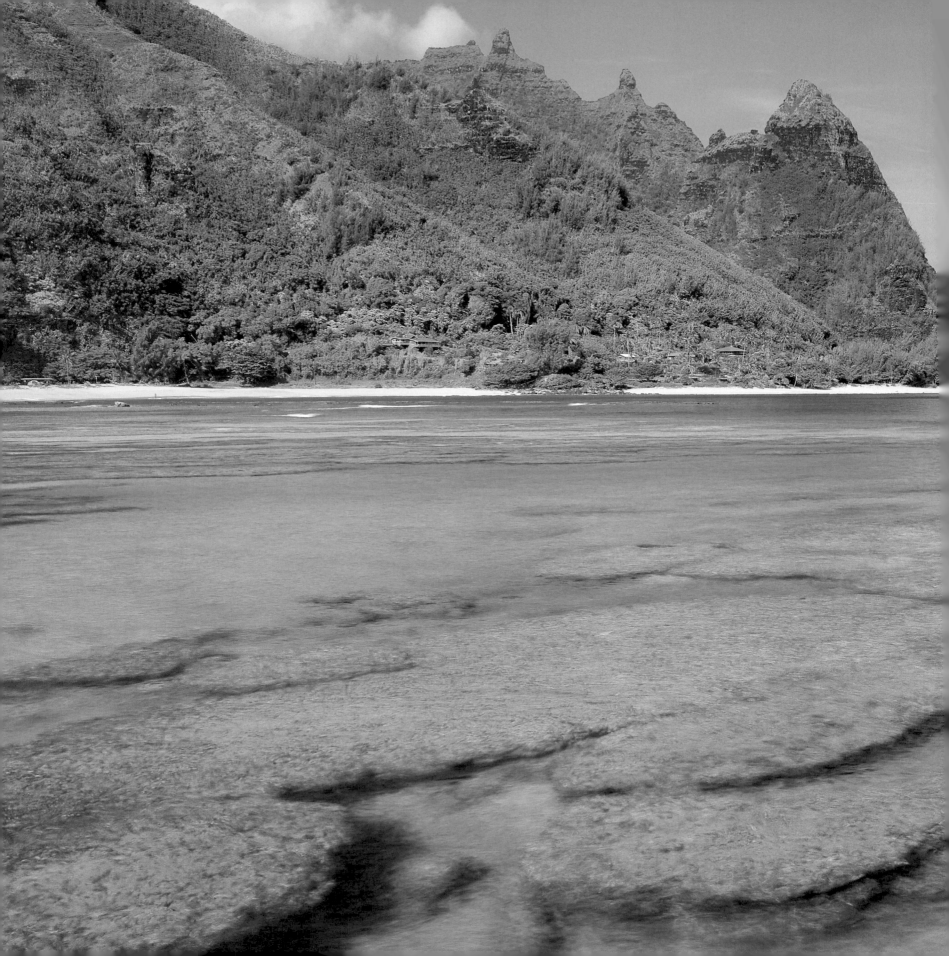

Kauai is the oldest of the Hawaiian Islands. For millions of years, volcanoes below the ocean's surface poured forth molten rock, until the highest of Kauai's summits was more than 5,000 feet above sea level. Erosion has since carved a dramatic landscape of steep canyons and cliffs.

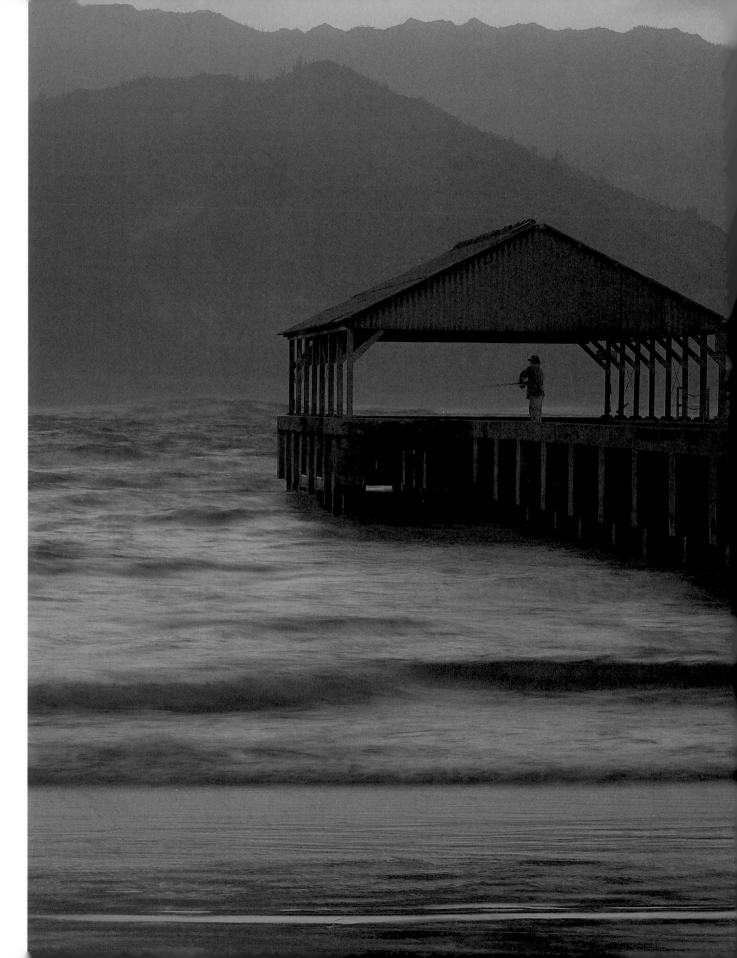

Sunset bathes Kauai's Hanalei Bay in a rosy glow. Protected by rugged cliffs on one side and a rocky point on the other, this is one of the north shore's most protected beaches.

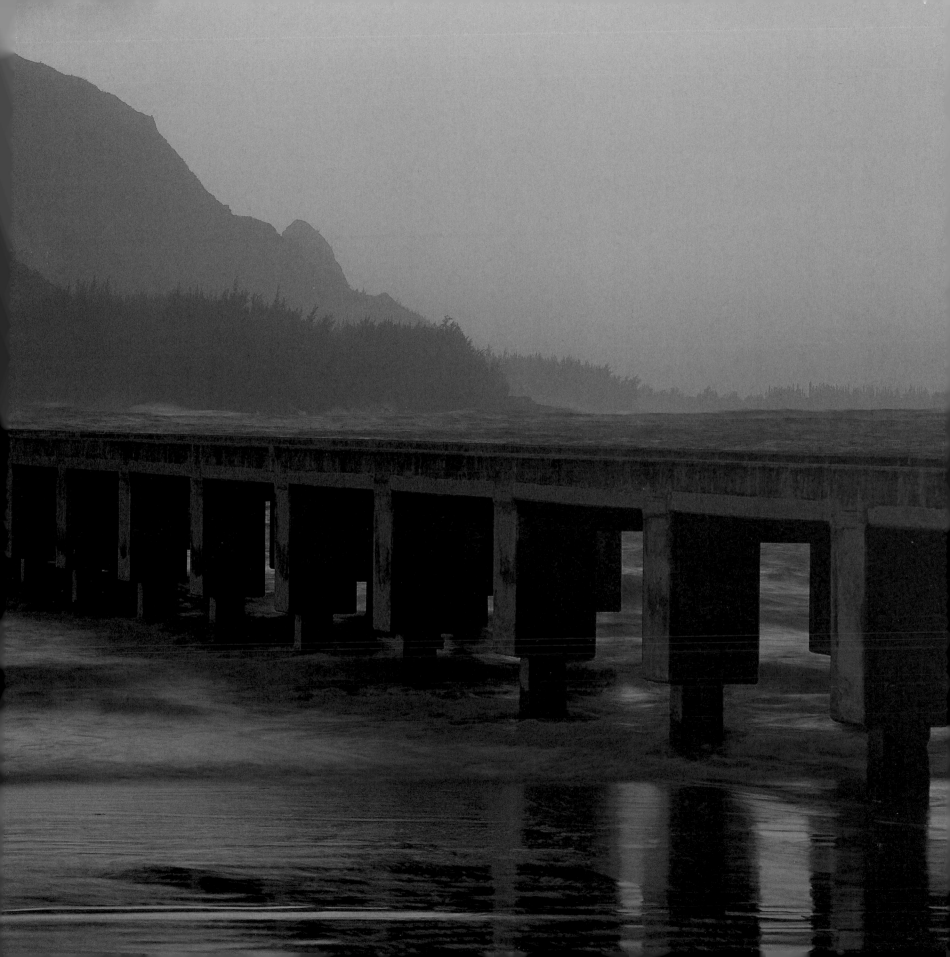

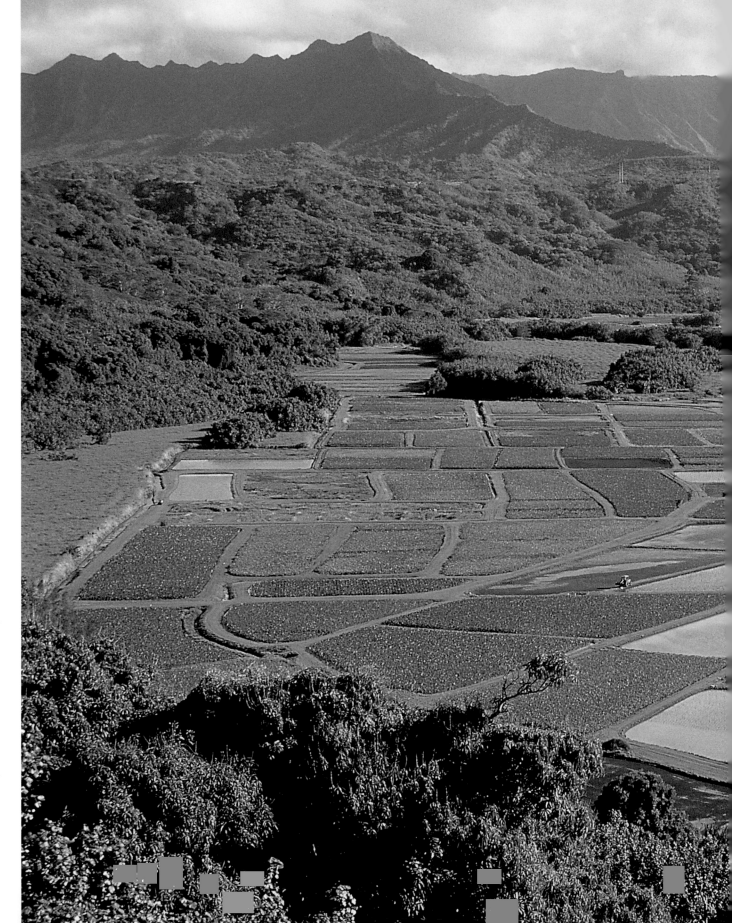

Lush Hanalei Valley is carpeted in taro fields. The crop contributes more than $3 million annually to the Hawaiian economy. Taro is a tropical plant with edible starchy roots and is used to make poi, one of the state's most traditional dishes. According to local custom, no one can argue while a dish of poi sits uncovered on the table.

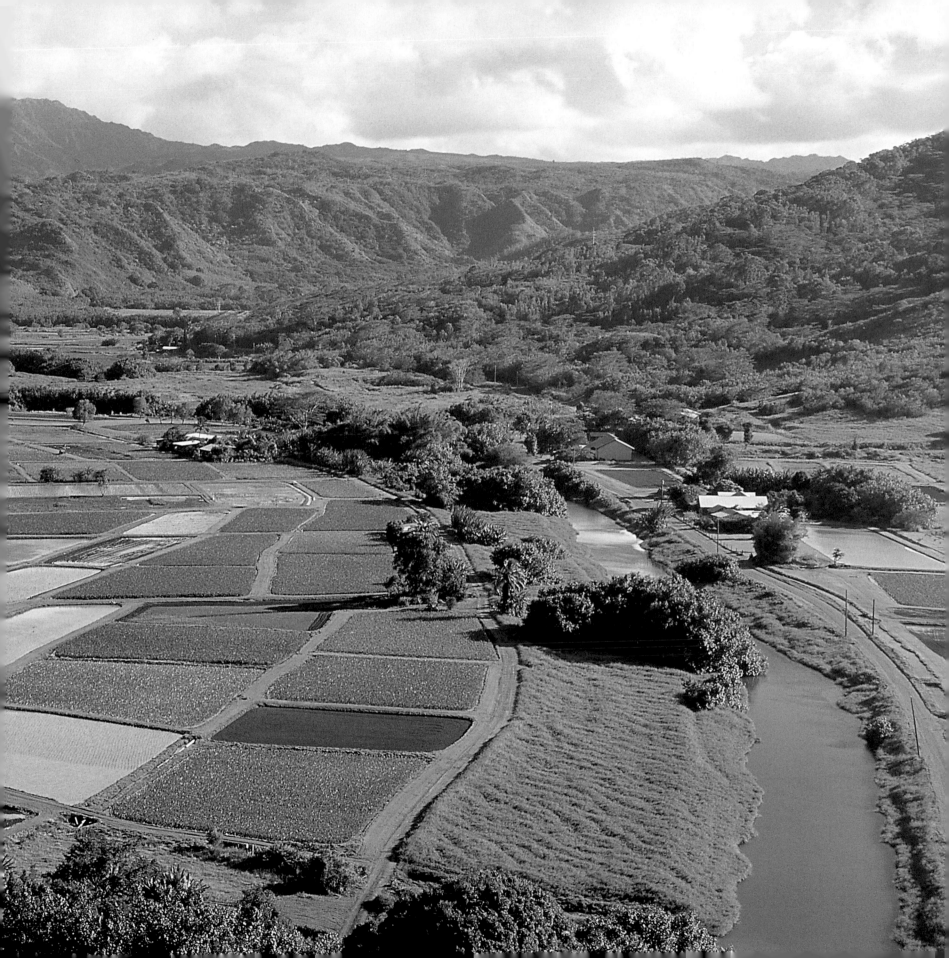

At the southern tip of Kauai, Poipu Beach is one of the island's most popular attractions. Miles of white sand tempt sunbathers, while snorkelers, scuba divers, boogie boarders, and surfers find abundant entertainment in the water.

FACING PAGE—
A road above the Hanalei Valley offers a sweeping view of the 4,000-foot-high Namolokama Mountains. Kauai's diverse landscape has drawn filmmakers for decades—*South Pacific, The Blue Lagoon, Raiders of the Lost Ark,* and *Jurassic Park* were all filmed here.

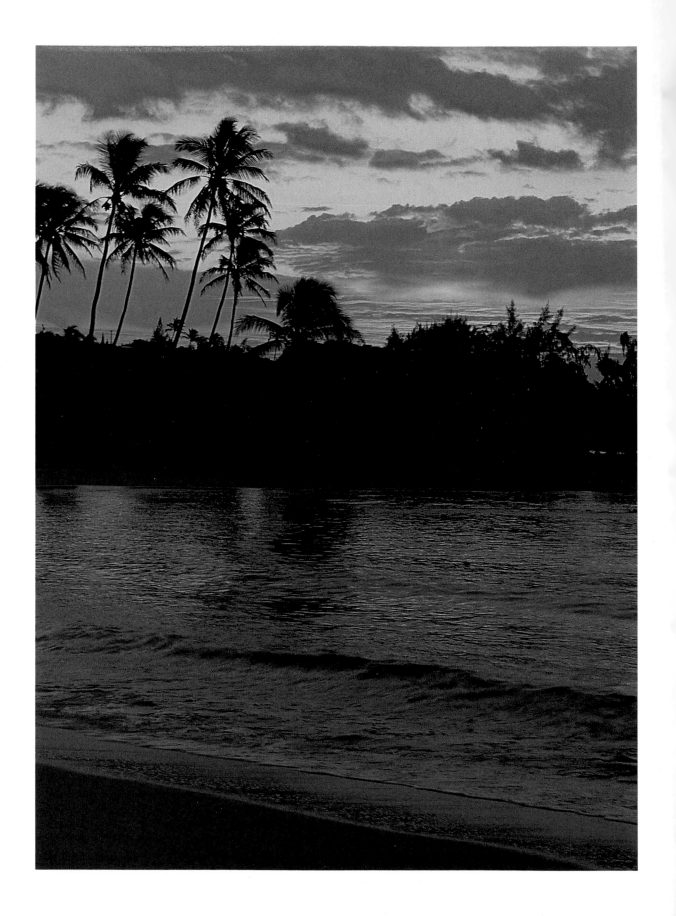

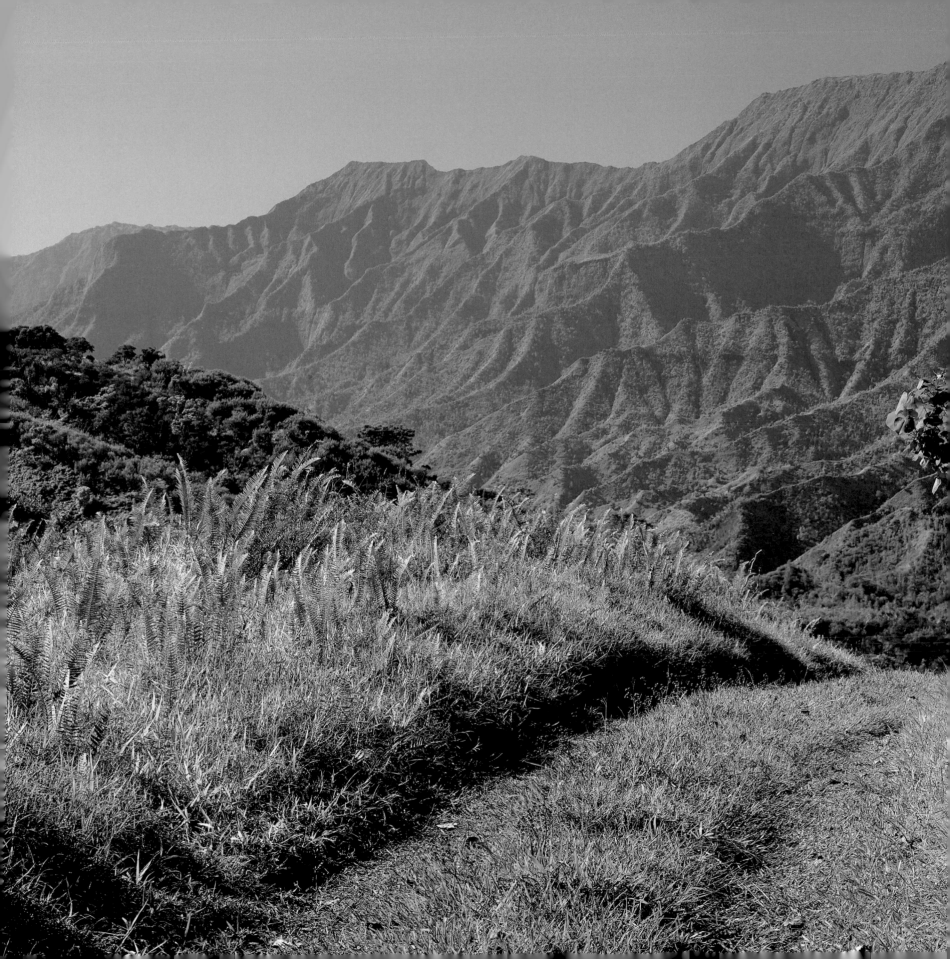

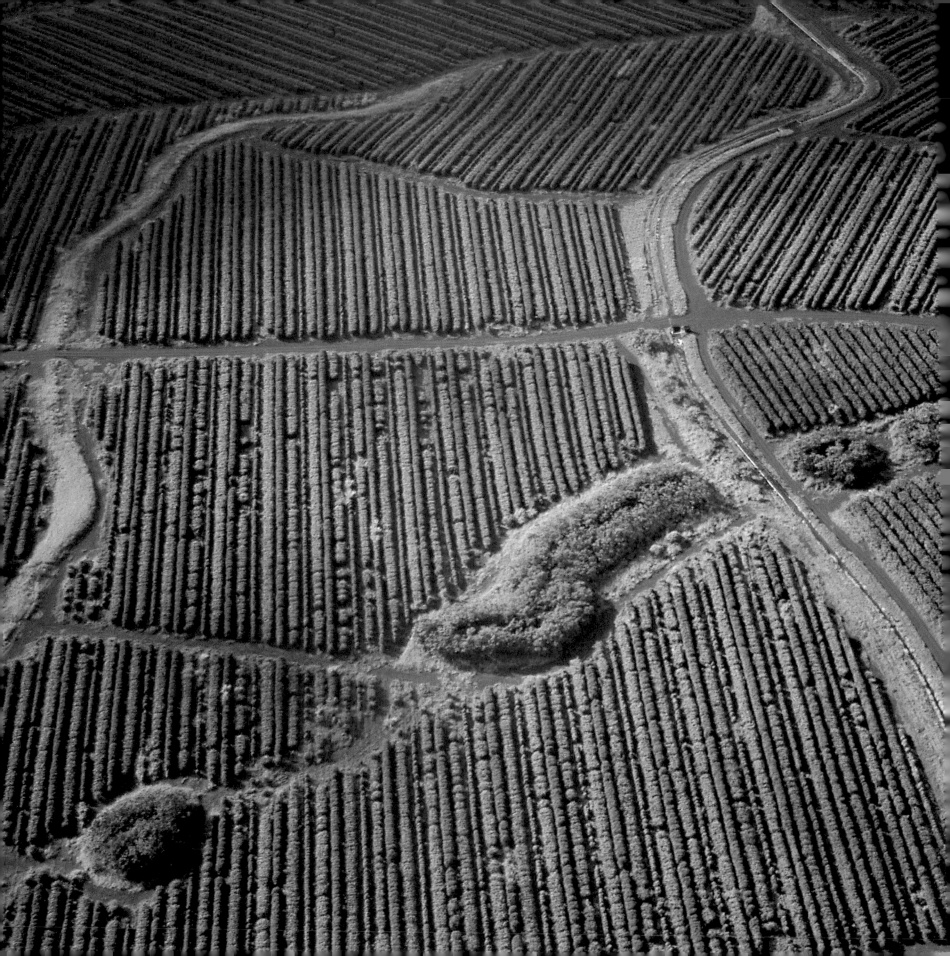

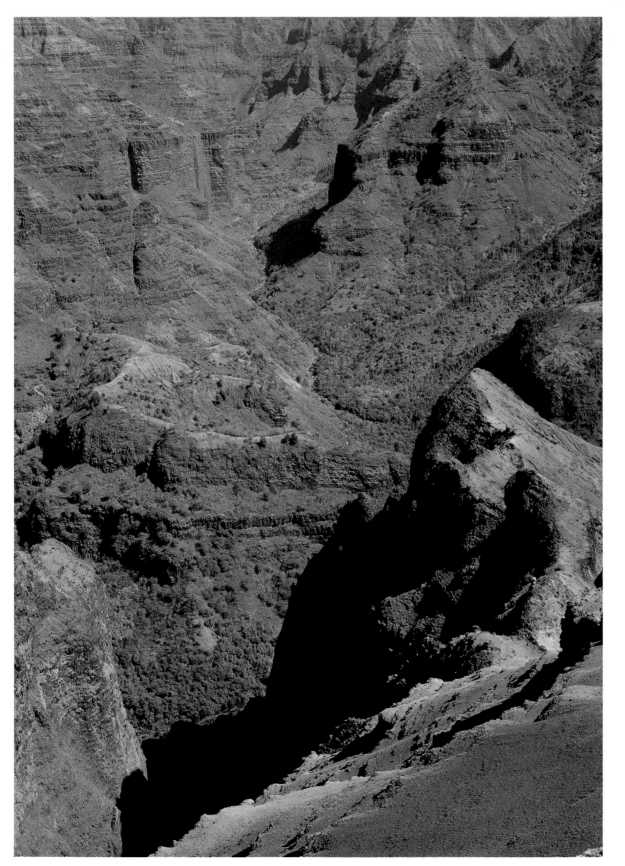

Mark Twain called Waimea Canyon the Grand Canyon of the Pacific. The 3,600-foot-deep gorge slices through 10 miles of Kauai's west side. A geological fault created some of the canyon's steep cliffs thousands of years ago. The Waimea River accomplished the rest, slowly eroding layers of volcanic rock.

FACING PAGE—
Coffee is one of Hawaii's best-known crops. At one Kauai farm, growers have planted coffee trees in the shade of indigenous hardwoods, perfecting an organic method of protecting, harvesting, and processing the beans.

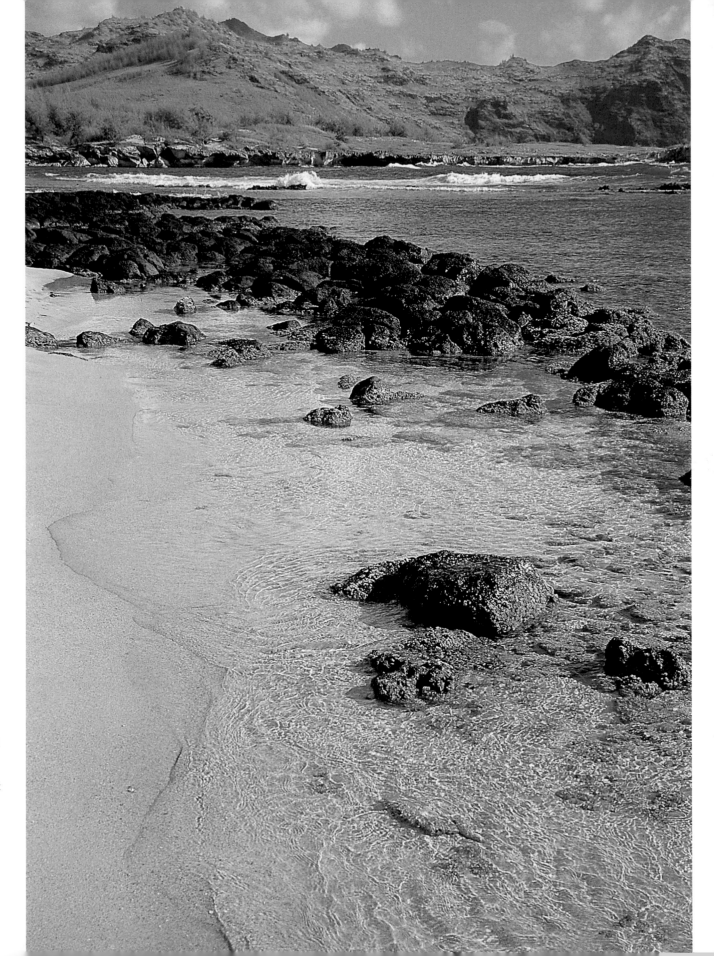

Only a small portion of Kauai is residential land. Fields of taro, sugarcane, and vegetables, along with pristine beaches and forest preserves, make up more than 95 percent of the island.

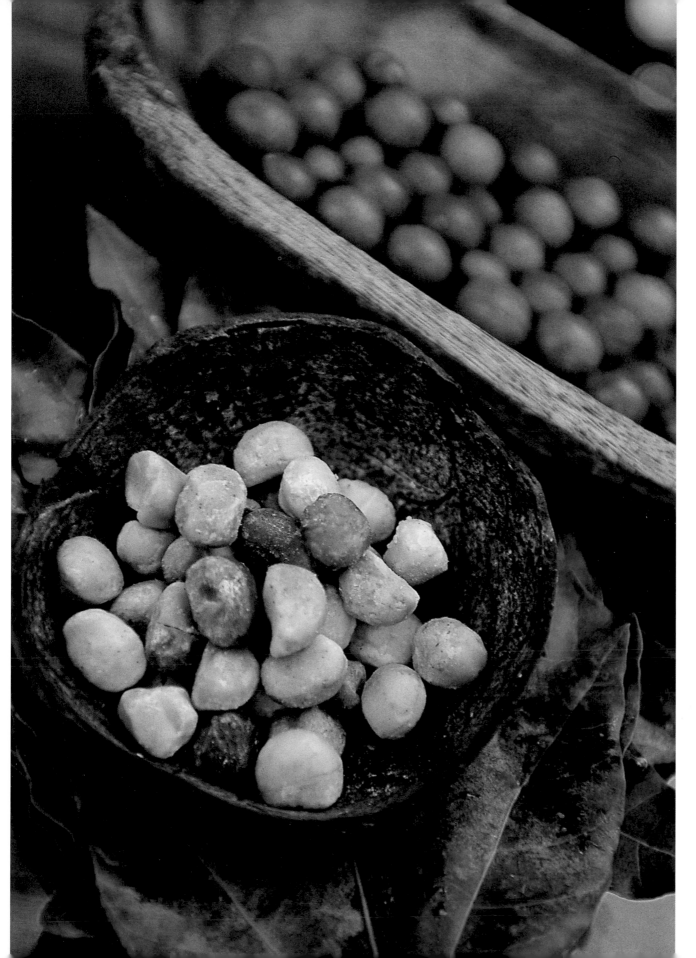

Hawaii's famous macadamia nuts come from plants native to Australia that were first planted commercially on the islands in 1921. Growing is expensive and labor-intensive—each tree must be partially picked five to six times a year.

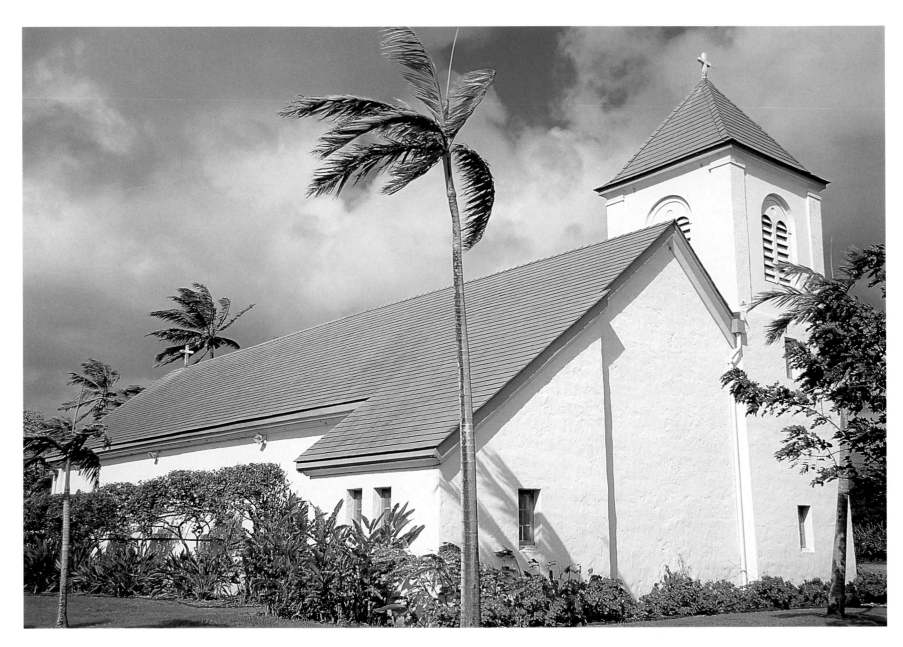

The oldest Catholic church on Kauai, St. Raphael's Roman Catholic Church was founded in the 1840s by Father Arsene Walsh, a missionary granted land by King Kamehameha III. The church stands in historic Old Koloa Town, founded as a sugarcane plantation in the early 1800s.

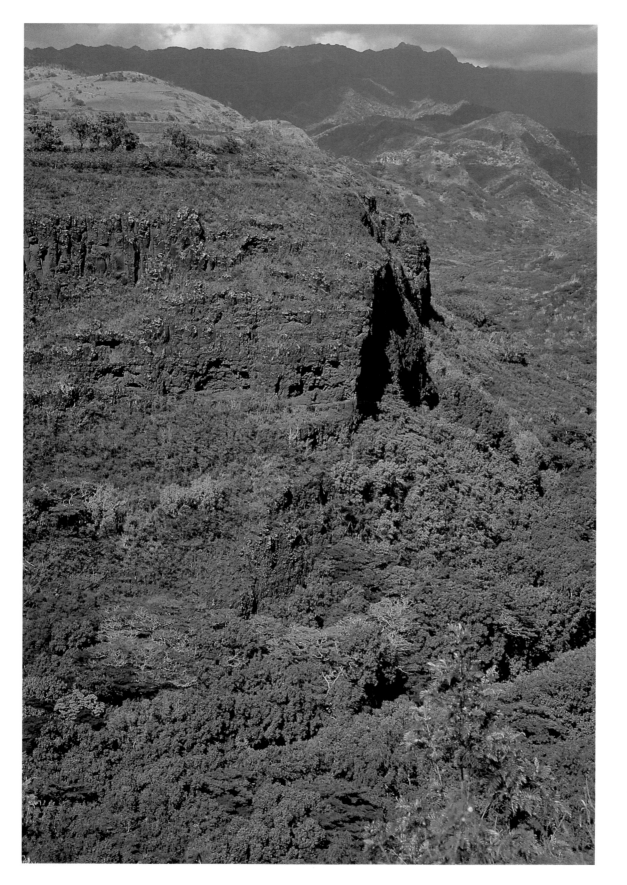

Steep Hanapepe Valley winds toward the ocean. *Hanapepe* means "bay crushed by landslides" in the Hawaiian language. Some of these landslides are caused by the 400 inches of rain that fall annually on Kauai, making this one of the world's wettest places.

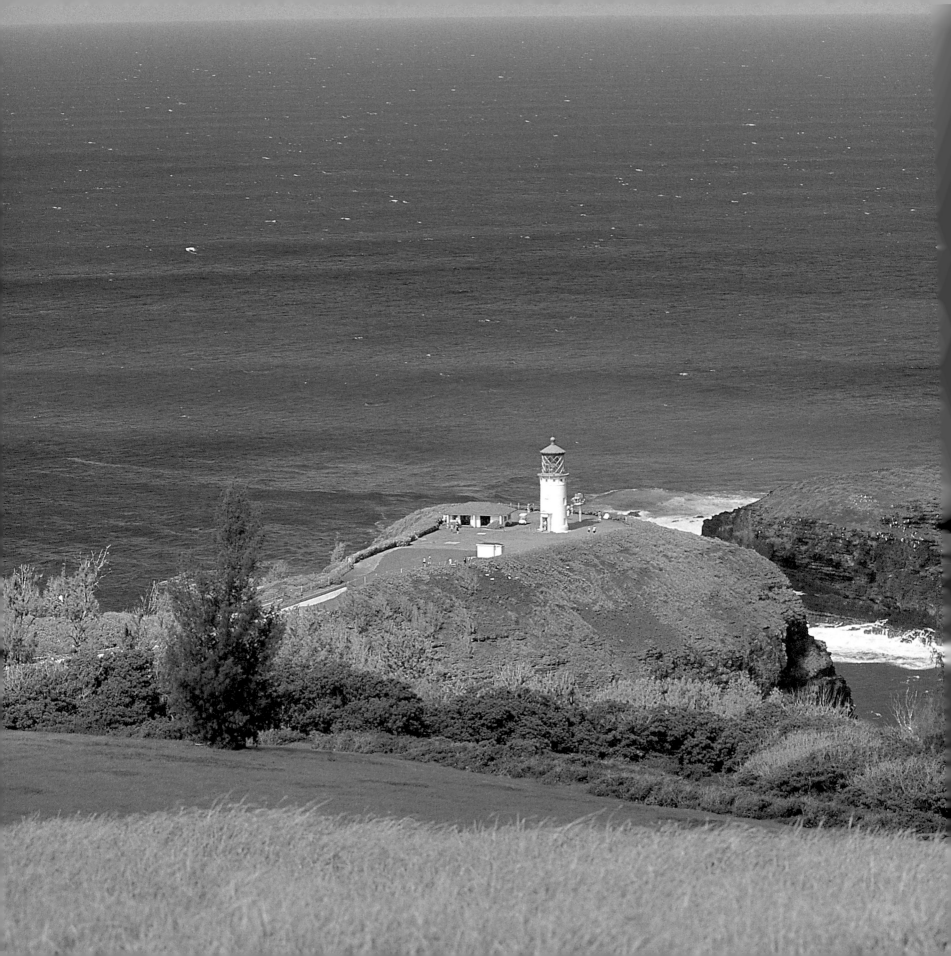

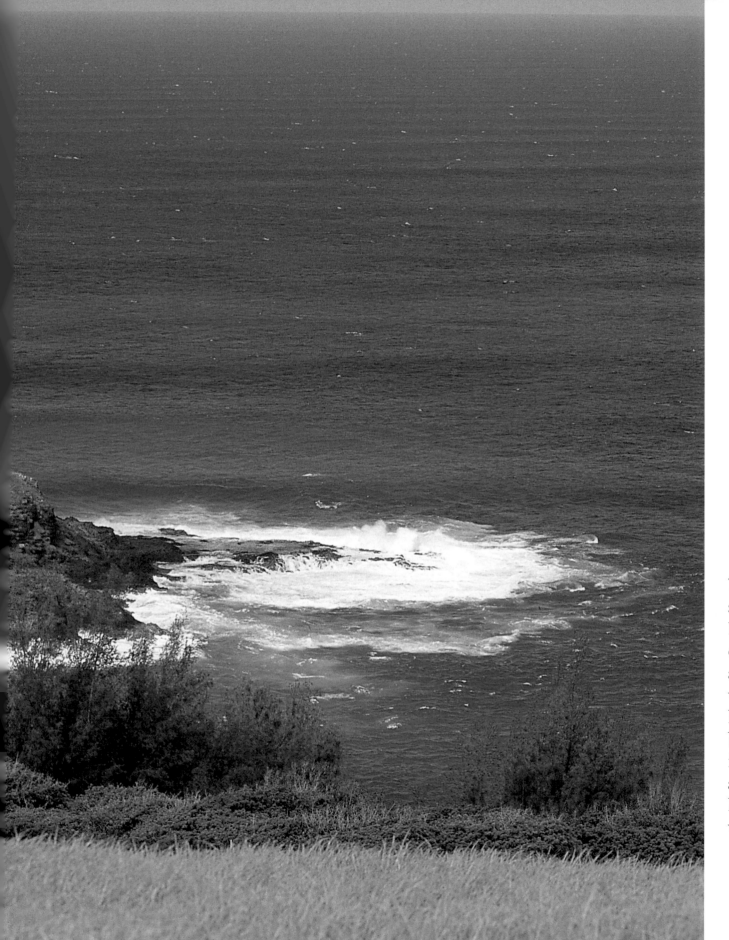

Though unused since 1976, Kilauea Lighthouse still stands on Kauai's north shore, a reminder of the days when this was the first light seen by sailors bound for Hawaii from Asia. The beacon and the nearby keeper's quarters were built in 1913.

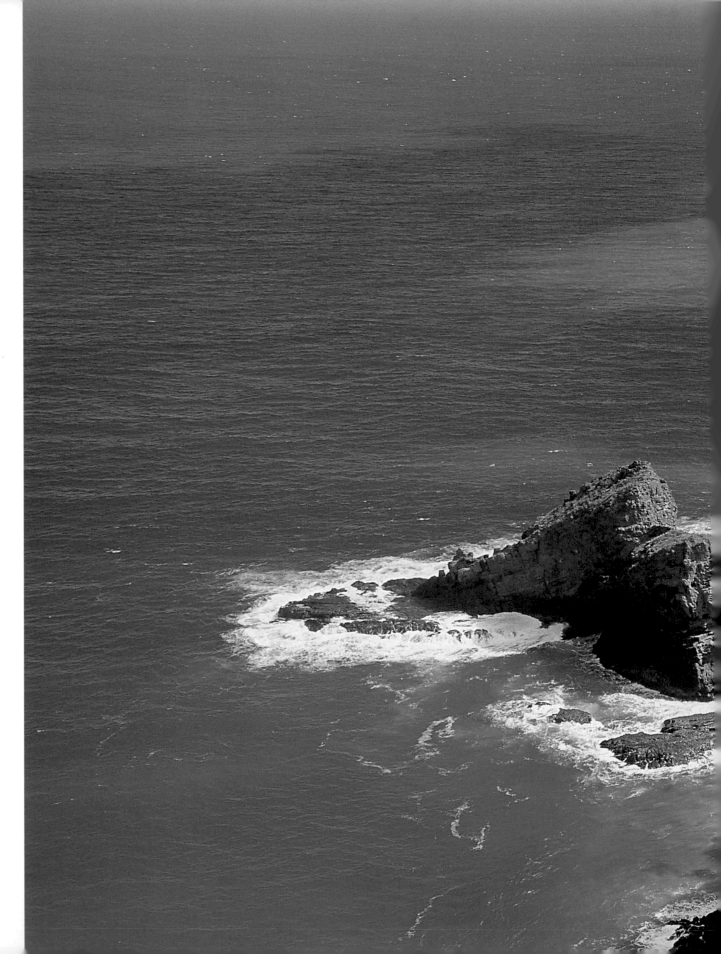

In 1979, the federal government established Kilauea Point National Wildlife Refuge on 31 acres surrounding the historic lighthouse. Mokolea Point, pictured here, and nearby Crater Hill were later added to the refuge, protecting the land from residential development and helping to preserve Kauai's endangered sea bird and nene (Hawaiian goose) populations.

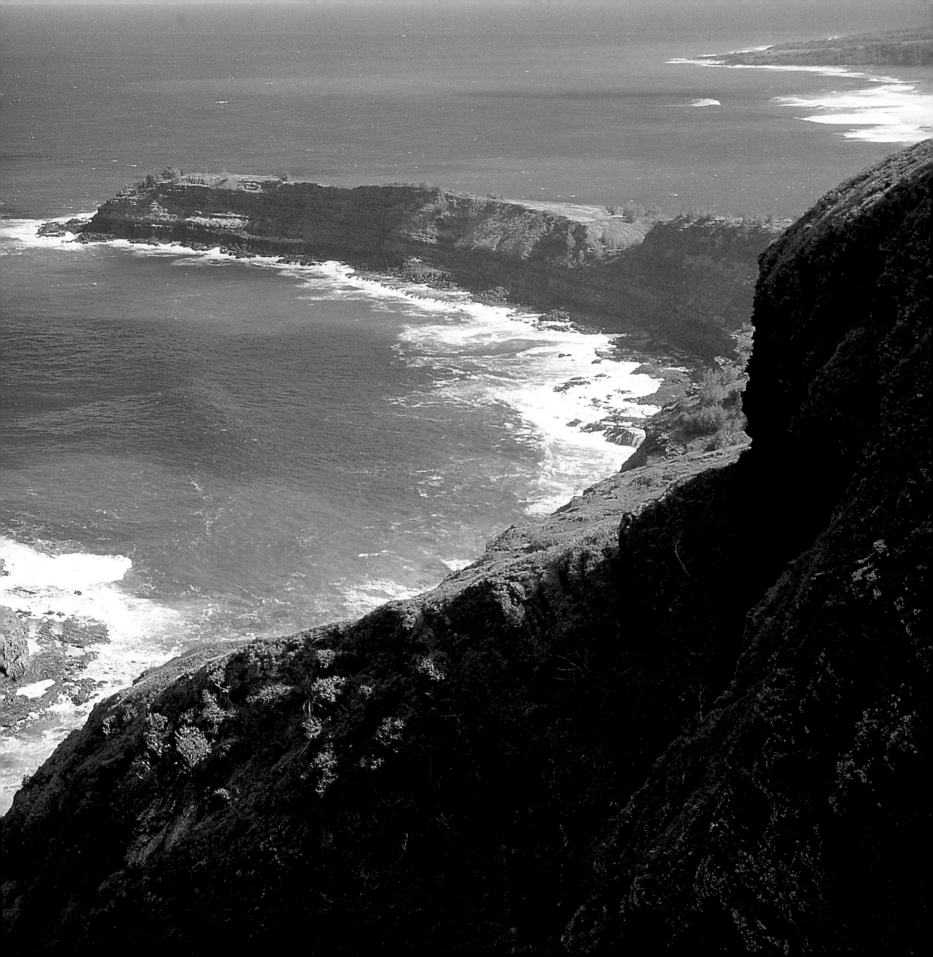

Honopu Valley on Kauai's north shore is known as the Valley of the Lost Tribe, for the Menehune people who are believed to have lived here after arriving from central Polynesia centuries ago.

FACING PAGE—
A hiking trail winds along Kauai's Na Pali Coast, clinging to the treacherous edges of the steep sea cliffs. For day hikers, the 11-mile Kalalau Trail offers a taste of the region's waterfalls and beaches, protected by Na Pali Coast State Park.

OVERLEAF—
The name of Honolulu, the state capital, means "sheltered harbor." English explorer Captain William Brown arrived in the bay in 1794, and in the century following, the city became a base for sandalwood, sugar, and pineapple export.

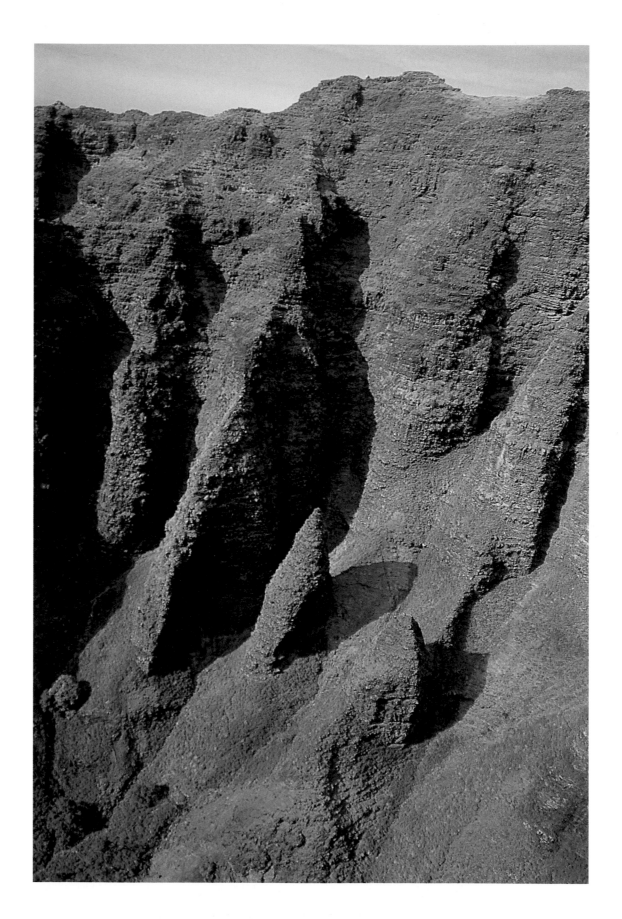

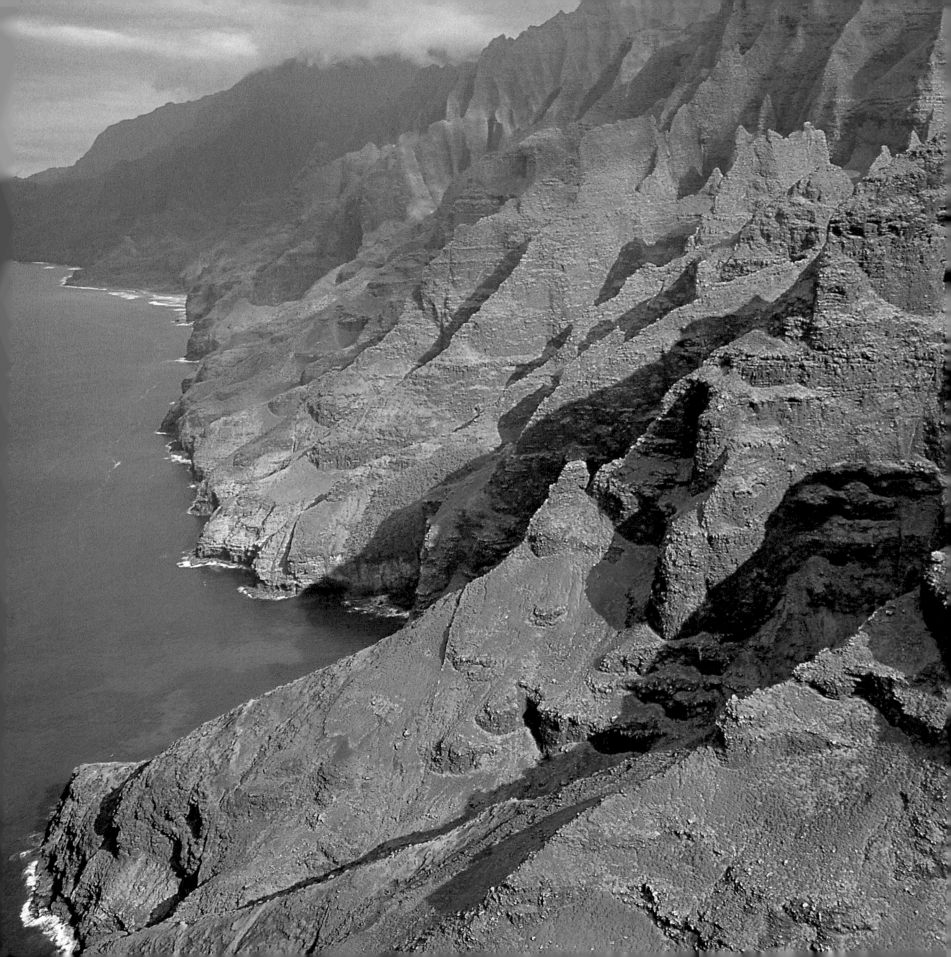

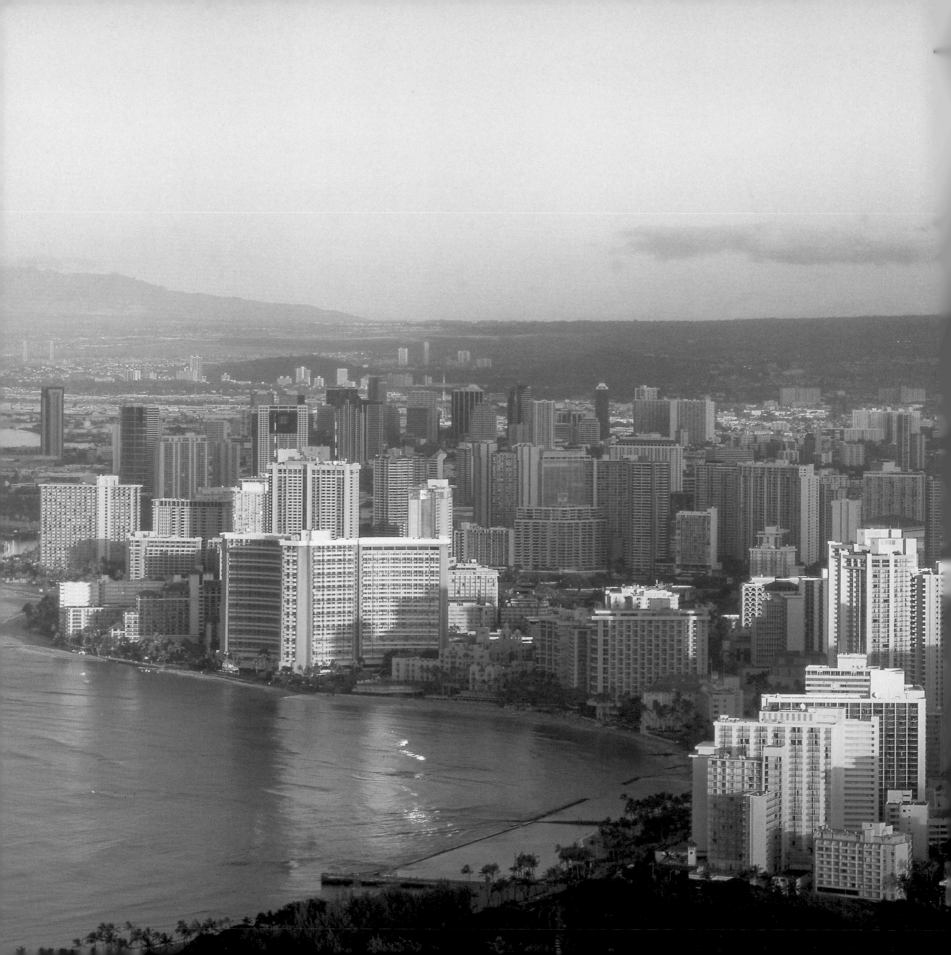

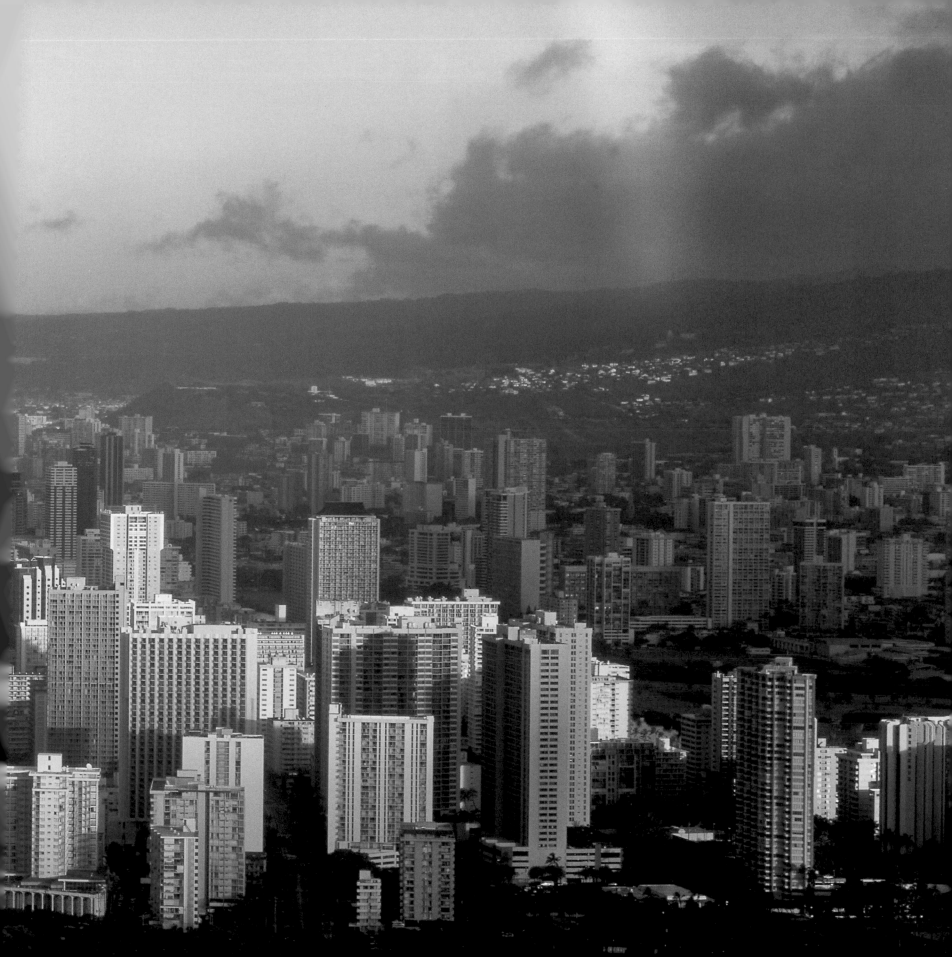

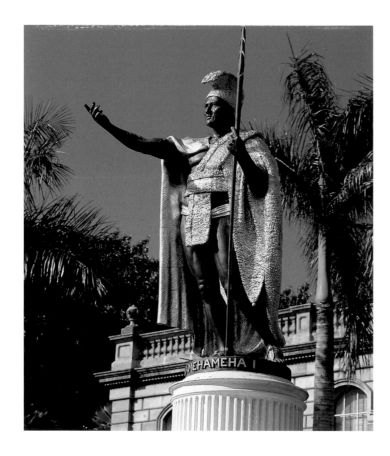

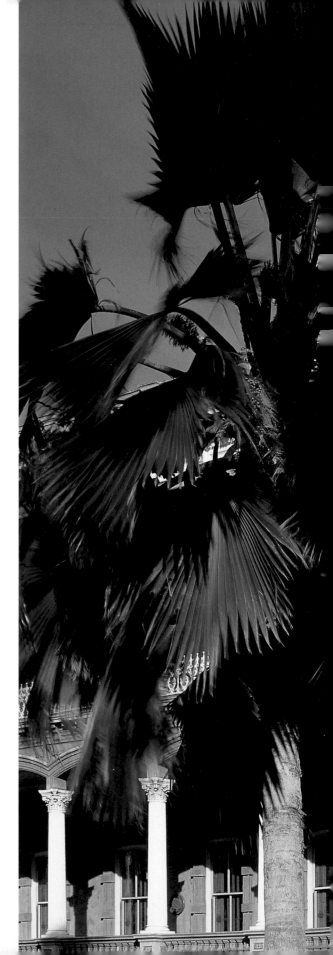

According to Hawaiian legend, King Kamehameha I was born as Haley's Comet streaked across the sky—a sign that he was destined for greatness. Kamehameha I was the first to unite the people of the Hawaiian Islands. He ruled at the end of the eighteenth century, balancing traditional culture with the influence of the newly arrived European explorers.

In 1882 King Kalakaua designed Honolulu's Iolani Palace—complete with telephones and electricity—after touring architectural wonders around the world. The palace was also home to Queen Lili'uokalani until 1893, when pressure from American businessmen forced her from her throne, and she surrendered Hawaii to the United States.

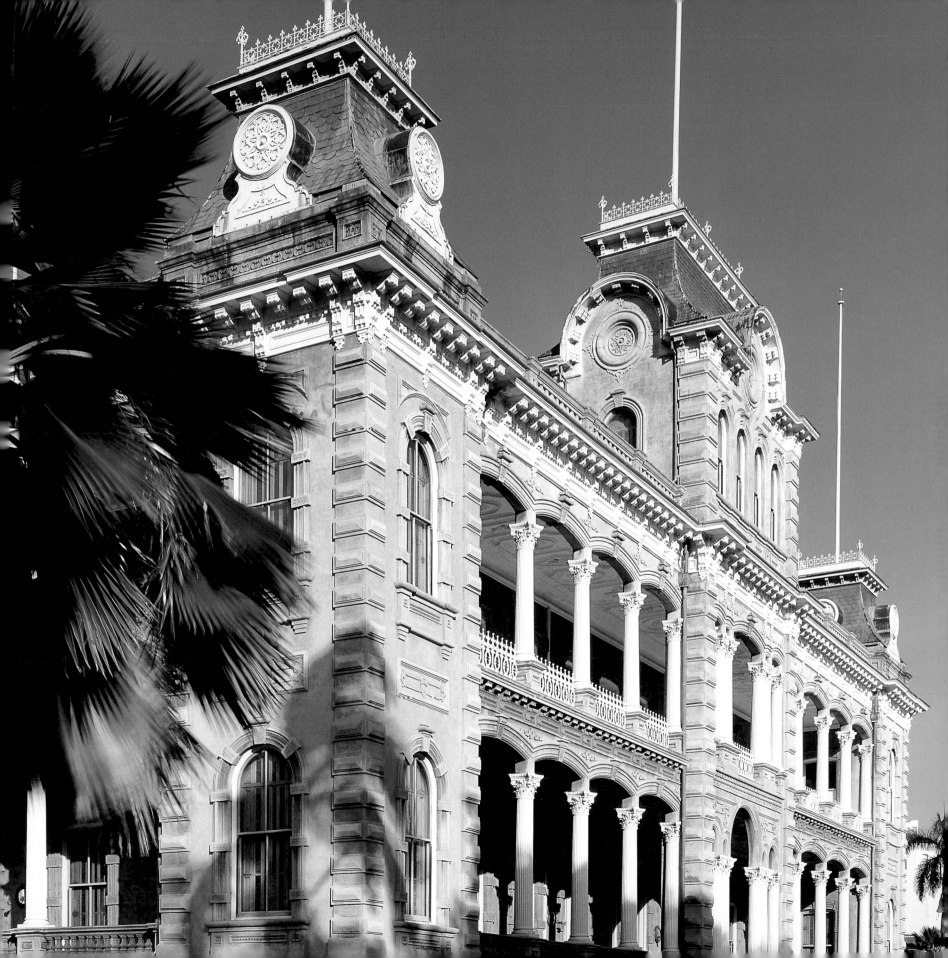

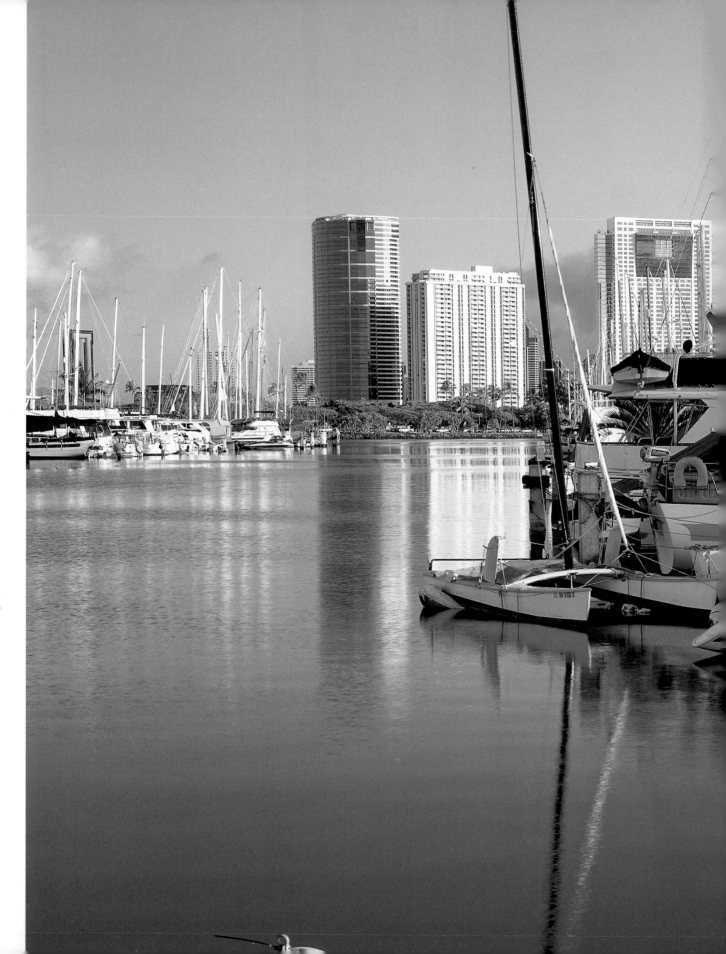

Sailboats find sheltered mooring along the Ala Wai Canal, built in 1922 to carry the rainwater from the mountains above directly into the Pacific. The newly drained land that resulted is now world-famous Waikiki Beach.

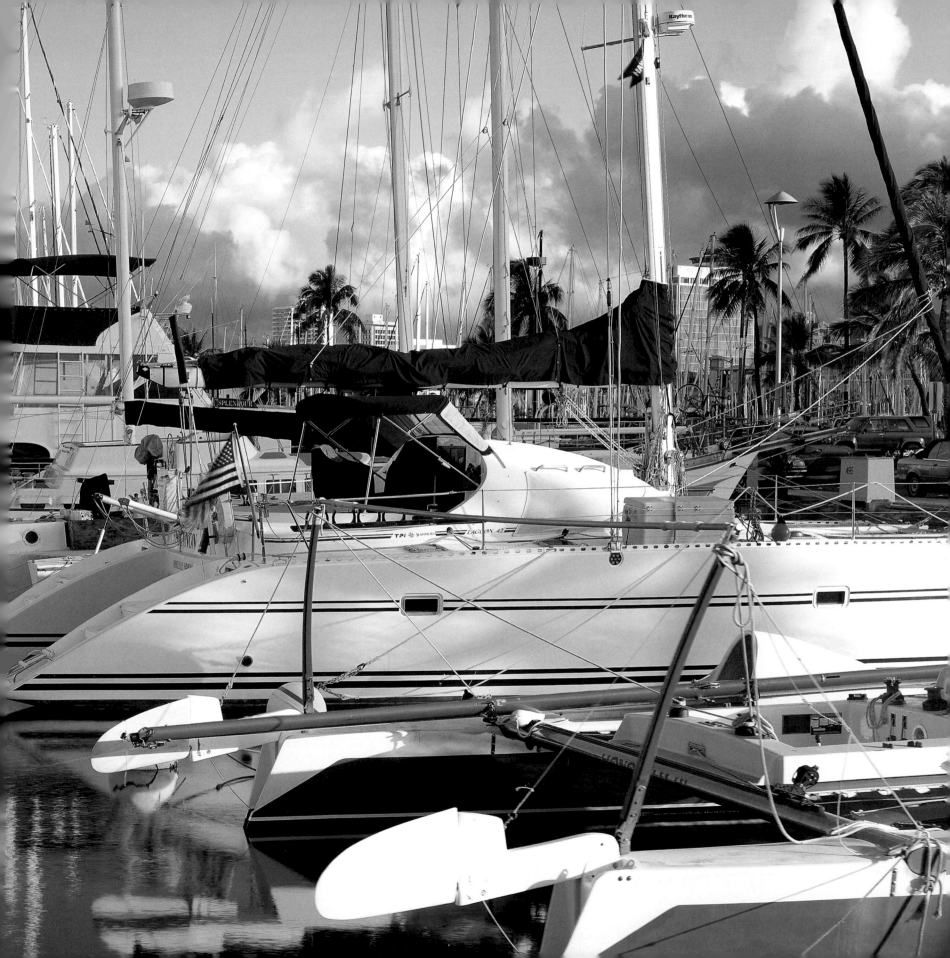

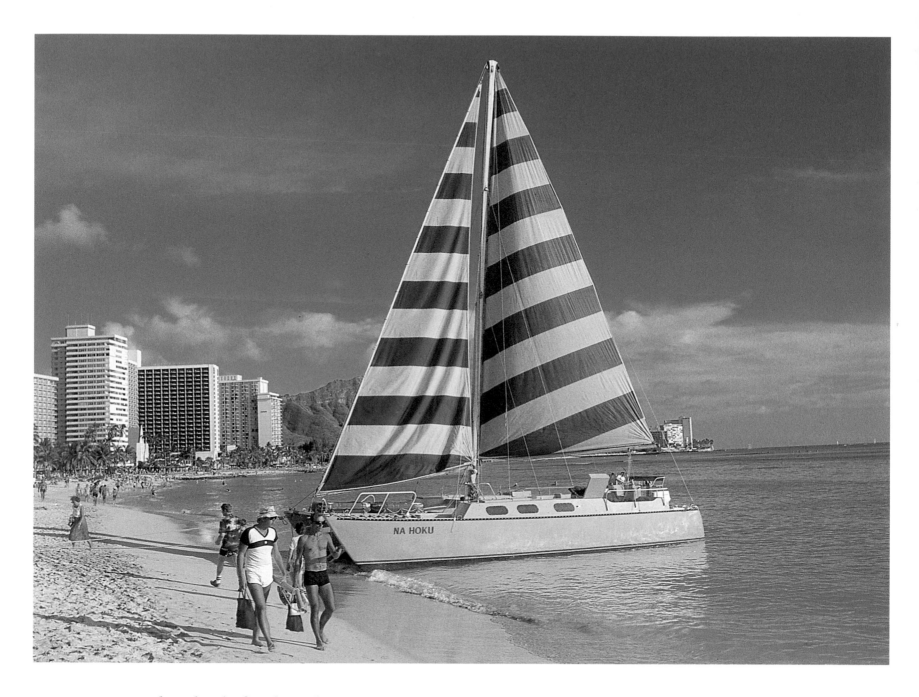

The island of Oahu is home to 870,000 people—three-quarters of the state's population. An additional 4.7 million people visit the island each year, most destined for the hotels, eateries, and nightspots lining Waikiki Beach.

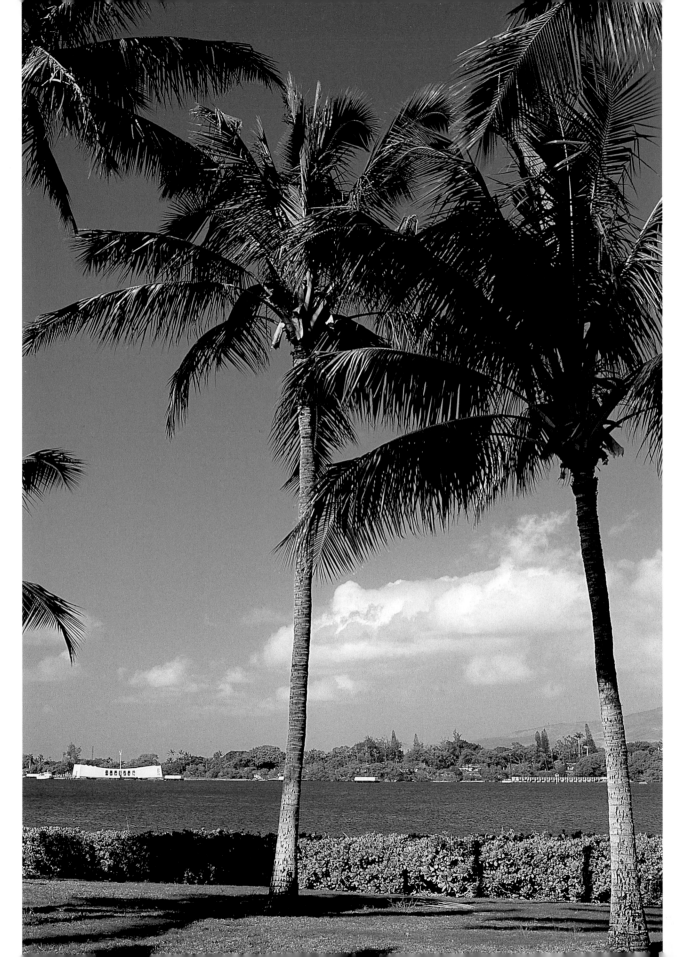

Built atop the sunken battleship, the USS *Arizona* Memorial stands in recognition of the 1,177 crew members and thousands of other personnel who died when Japan bombed Pearl Harbor on December 7, 1941. Architect Alfred Preis designed the bowed center of the monument to represent initial defeat and the rising ends to symbolize victory.

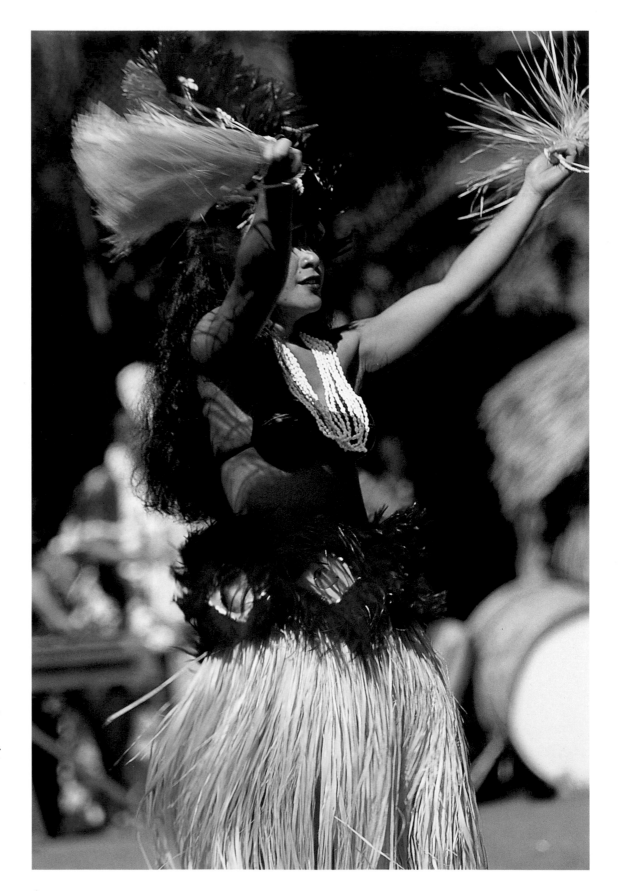

Missionaries in Hawaii in the early 1800s saw the hula as a pagan ritual and banned it. For decades, performances were clandestine. King David Kalakaua, despite Christian protest, sponsored a resurgence of the hula and other traditional Hawaiian arts later in the century.

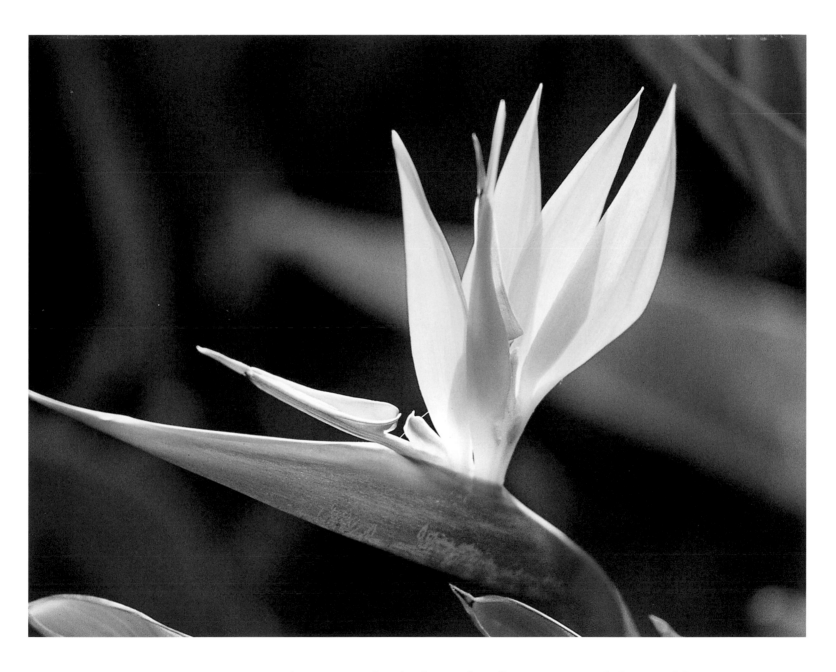

Growers in Hawaii ship orange bird of paradise flowers around the world. Blooming on stalks up to five feet high, the brilliant flower is native to South Africa. It flourishes in Hawaii's tropical gardens.

It is believed that the Polynesians began "wave-sliding" as early as the fourteenth century. Today, surfing instructors at Waikiki Beach guarantee that beginners will learn to stand up on their boards within the first lesson.

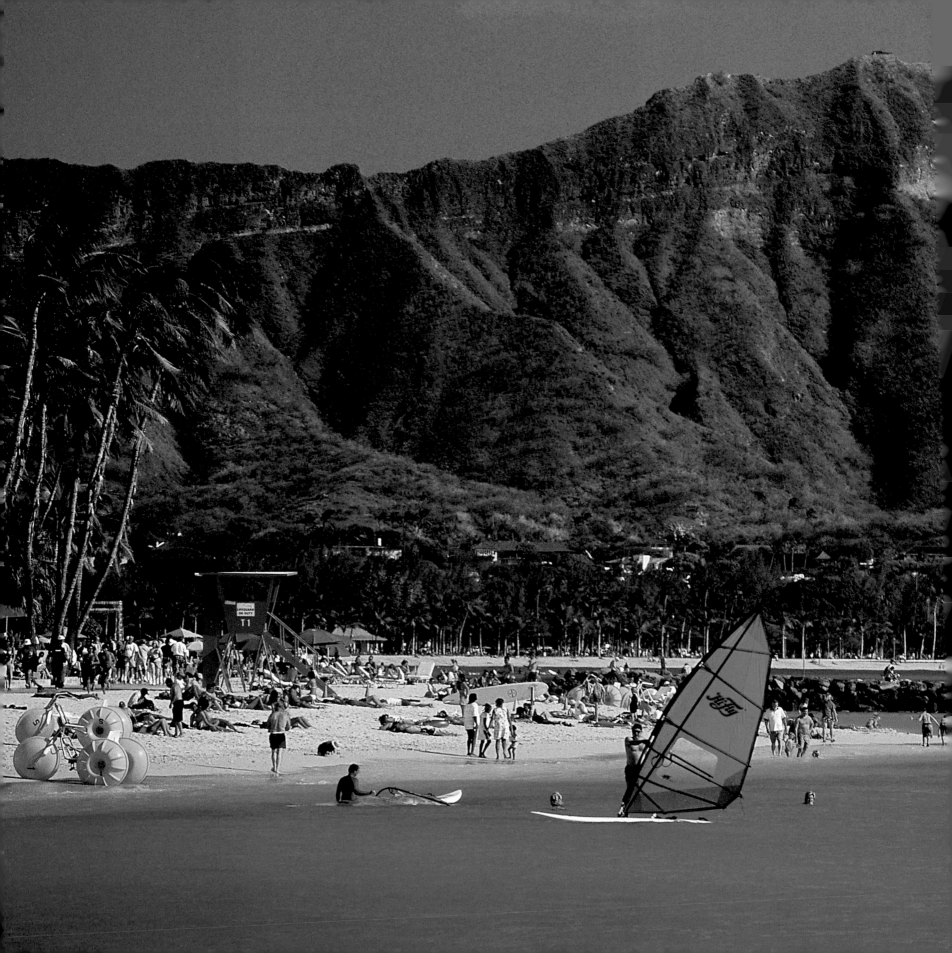

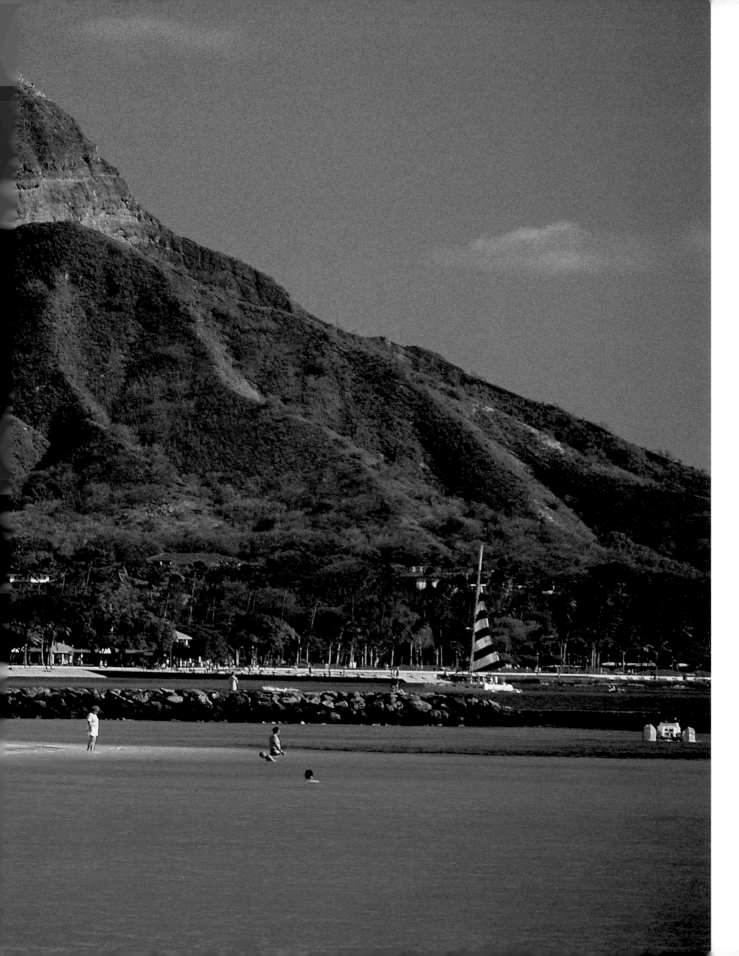

Extinct for 150,000 years, Diamond Head rises from the white sands of Waikiki Beach. Early Hawaiians called the volcano Laeahi, or "brow of the tuna," but European sailors renamed it after seeing crystals sparkling in the rock. Steep stairways and an unlit tunnel lead adventurous visitors within the crater.

At hundreds of hotels, staff light tiki torches at poolside, along the beachfront, and throughout the gardens to usher in the evening. Traditional Hawaiian torches burned the oil of the kukui nut. The candlenut tree was one of the plants brought to the islands by the Polynesian settlers.

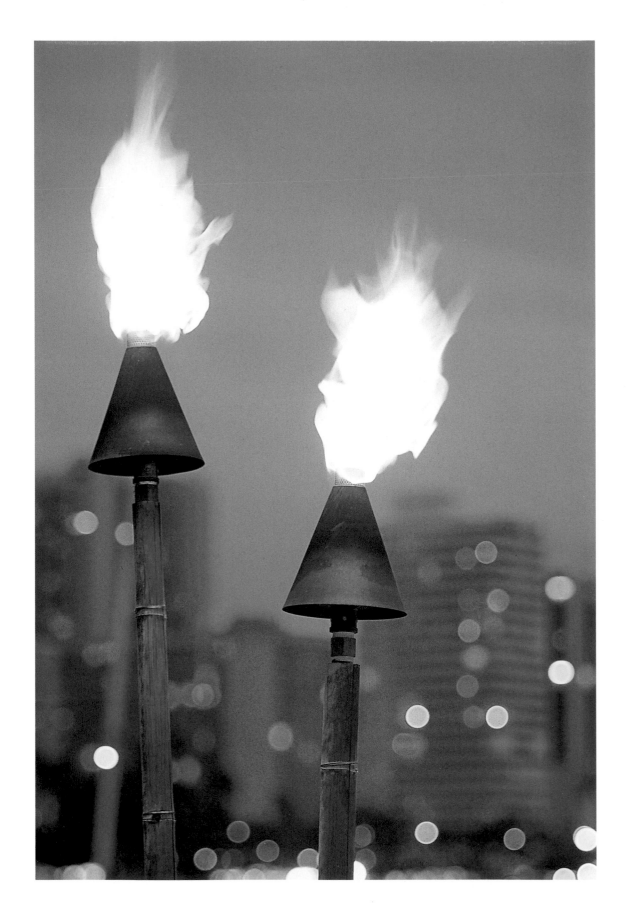

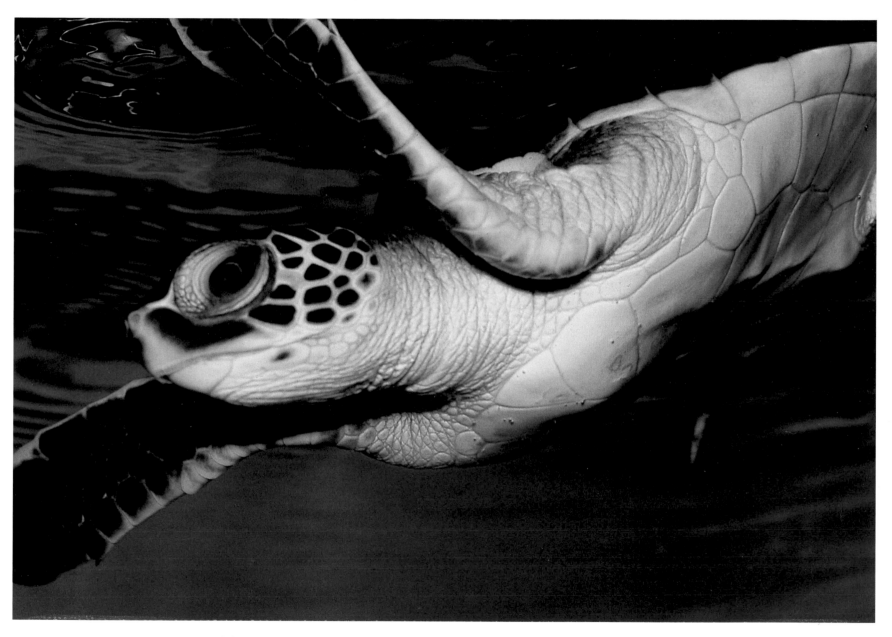

Established in 1904, Waikiki Aquarium is the oldest in the nation and is home to 2,500 creatures. Green sea turtles such as this one have lived in the waters of the Pacific since the time of dinosaurs. Threatened by overhunting and shoreline development, sea turtle populations are slowly increasing once again.

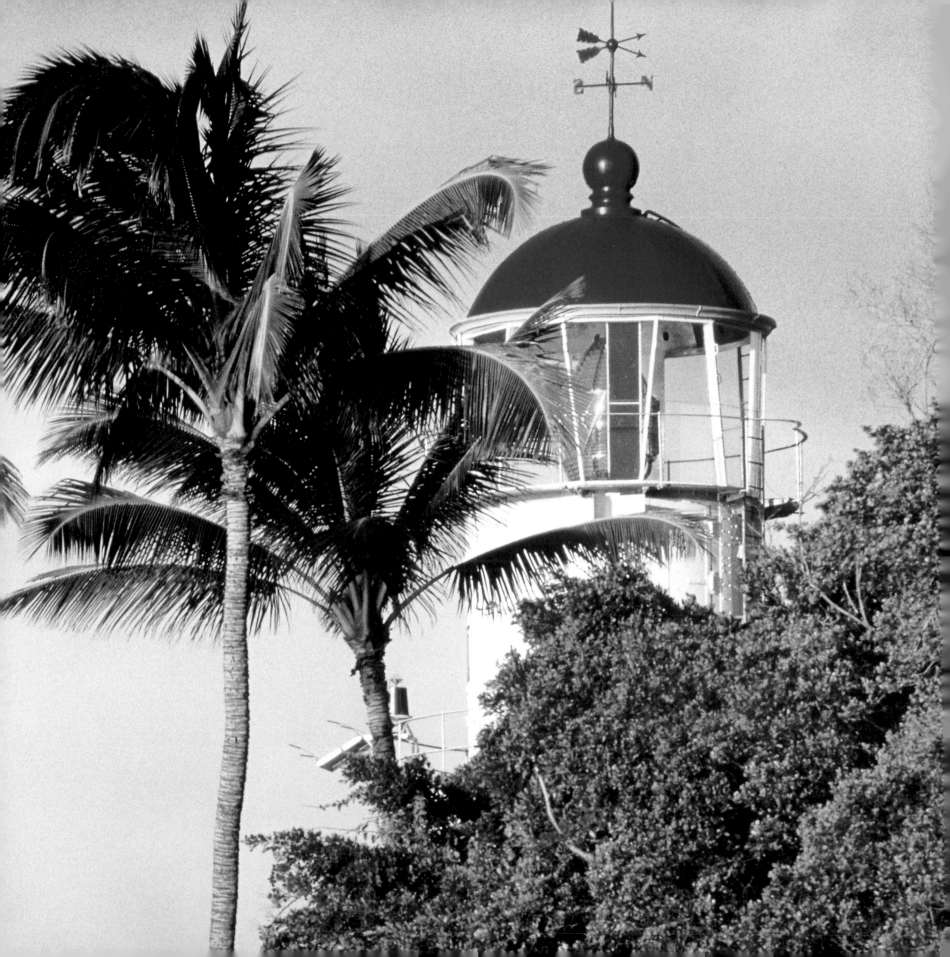

Diamond Head Lighthouse stands guard over the reefs of Waikiki Beach. Built in 1917, the lighthouse uses the fresnel lens from an earlier 1899 beacon. Though the light is now automated, the refurbished keeper's quarters are home to the local Coast Guard commander.

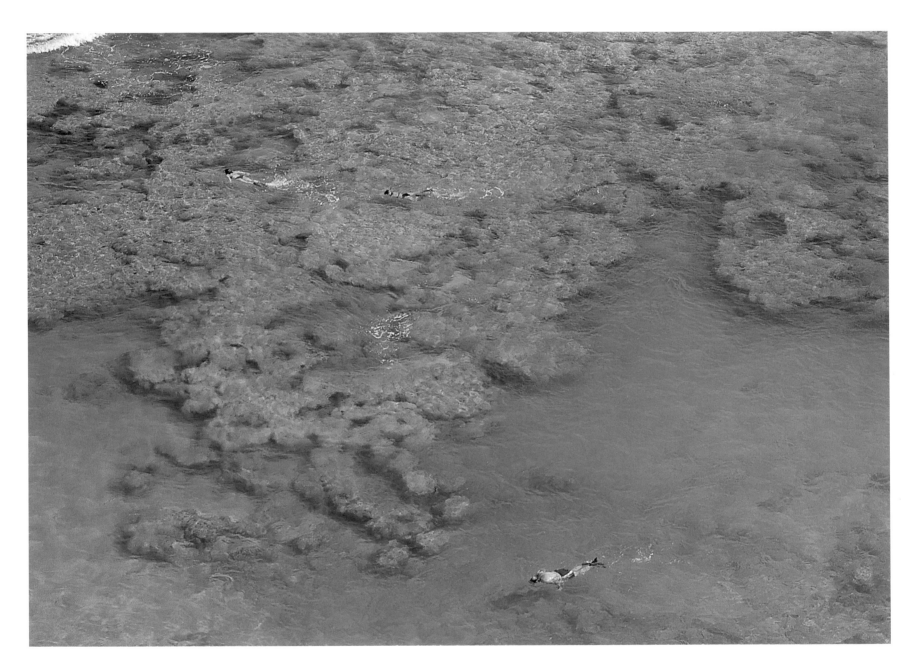

The coral reefs within the waters of Hanauma Bay are clearly visible from the cliffs above. Most of the fish are accustomed to the daily snorkeling crowds, and parrot-fish, yellow tangs, Moorish idols, and butterfly fish swim close to shore, along with the occasional green sea turtle.

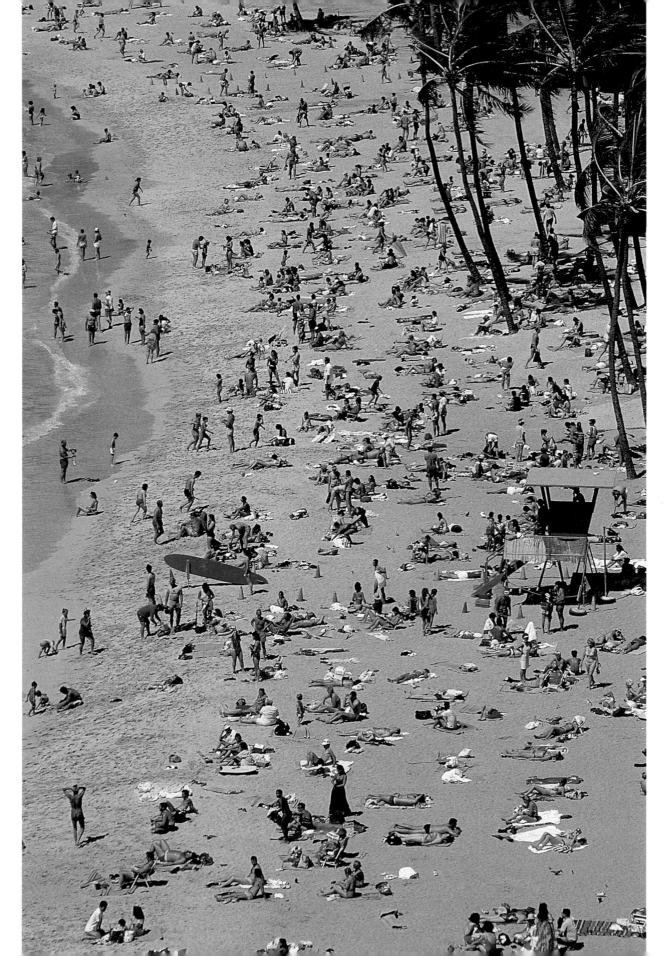

The Koko Head Crater
was once an active
volcano. Now, waves
have breached the
rim, filling the crater
with salt water and
forming spectacular
Hanauma Bay. Within
the protected waters,
a white sand beach,
living coral reef, and
vibrant tropical fish
draw almost a million
tourists to snorkel,
dive, and sunbathe
each year.

Built in 1968,
Byodo-in Temple is
a replica of a 900-
year-old structure in
Uji, Japan. Oahu's
version includes a
lush Japanese
garden, carp pool,
flowing waterways,
and a three-ton bell.
The temple reflects
the influence of
Japanese visitors
and immigrants
on modern
Hawaiian culture.

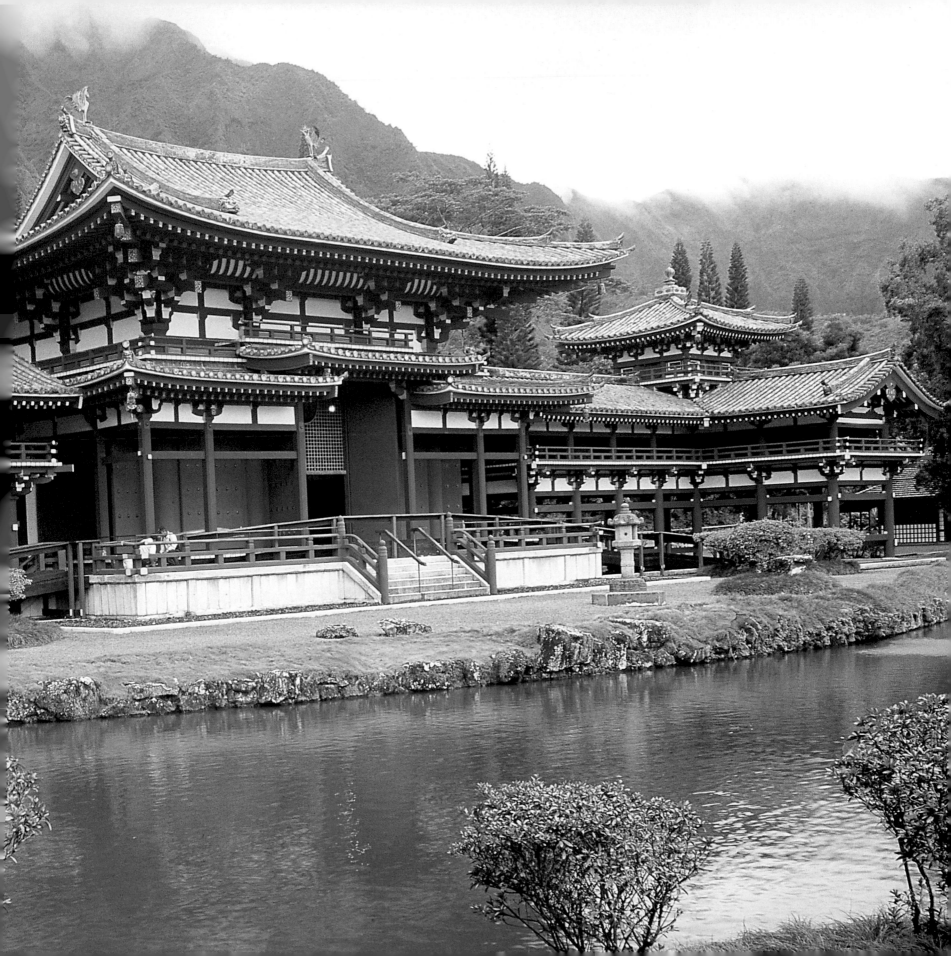

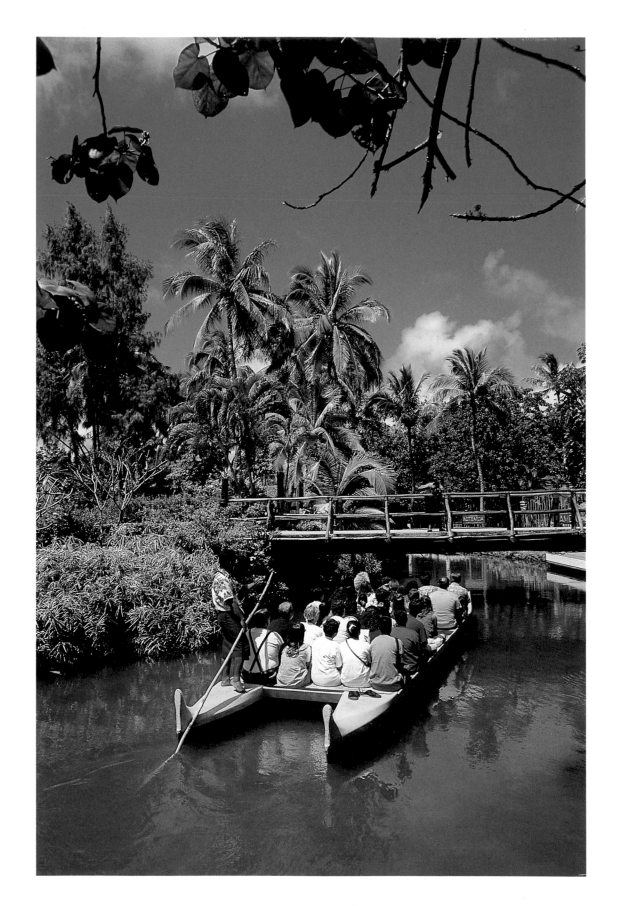

Visitors to the Polynesian Cultural Center on Oahu discover the customs of seven diverse Polynesian peoples, from the aboriginal inhabitants of New Zealand to the people of Tonga. Exhibits explain how Hawaiian ancestors journeyed across the Pacific to the islands.

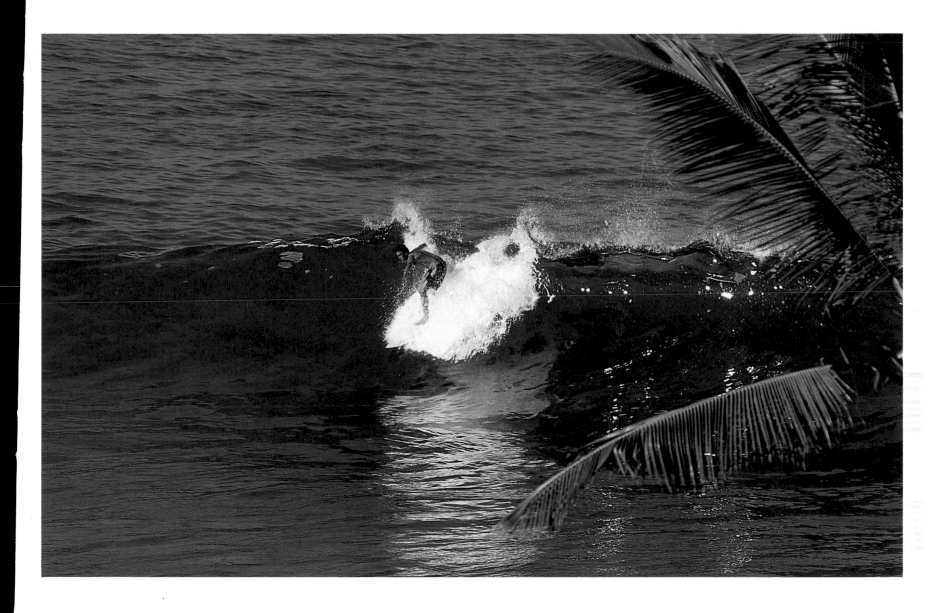

On the eastern shore of Oahu, the beach at Kailua is a favorite with boogie boarders, kite-surfers, windsurfers, and kayakers. Nearby vacation homes offer all the sun and sand of Oahu without the crowds of Waikiki.

Overleaf—
Just moments away from Kailua, Lanikai Beach is sheltered by offshore reefs and islands. For visitors looking for more active pastimes, a hiking trail leads to the mountain ridge above the beach, offering panoramic views of the waters below.

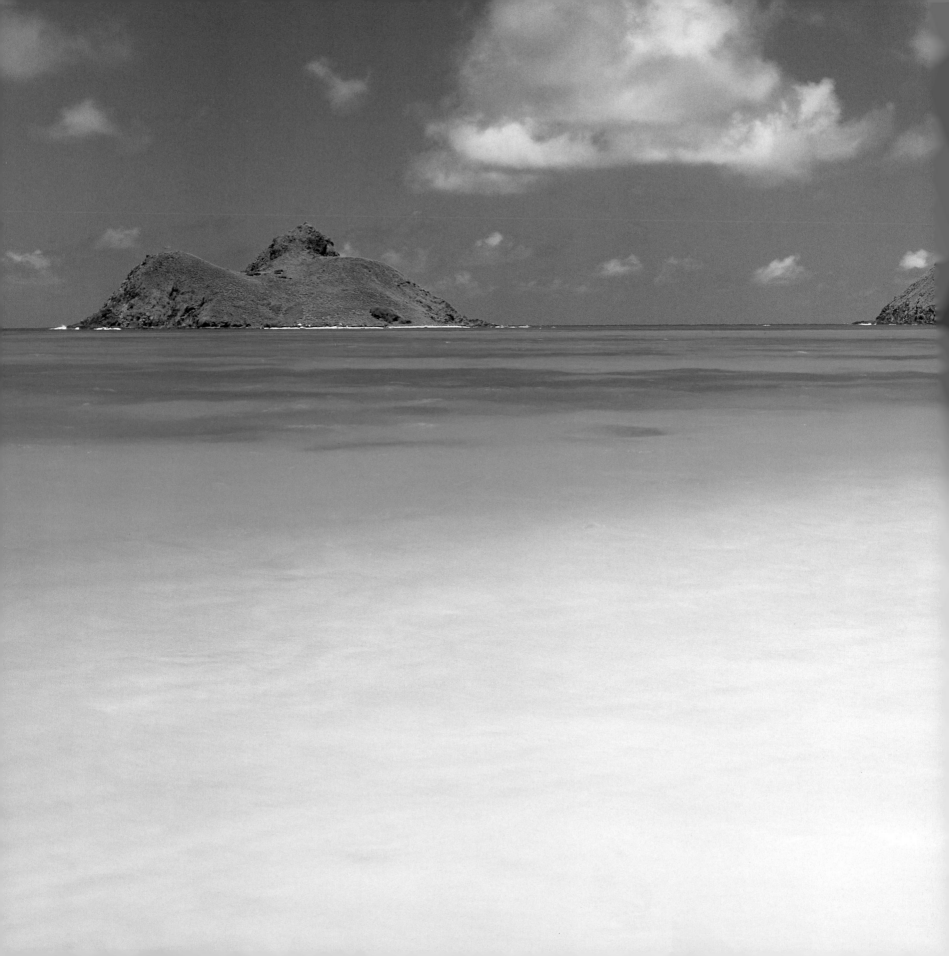

A number of European settlers experimented with growing pineapples in Hawaii in the early nineteenth century. The most successful of these was Jim Dole, known locally as the pineapple king. At Oahu's Dole Pineapple Plantation, there are 27,000 to 33,000 plants per acre, and pineapples are hand-picked and shipped around the world.

FACING PAGE—
Hawaii's highest waterfall, Papalaua Falls cascades 1,200 feet down the steep cliffs of Molokai's northern tip. The 38-mile-long island remains largely undeveloped, and Molokai has no buildings taller than a coconut tree.

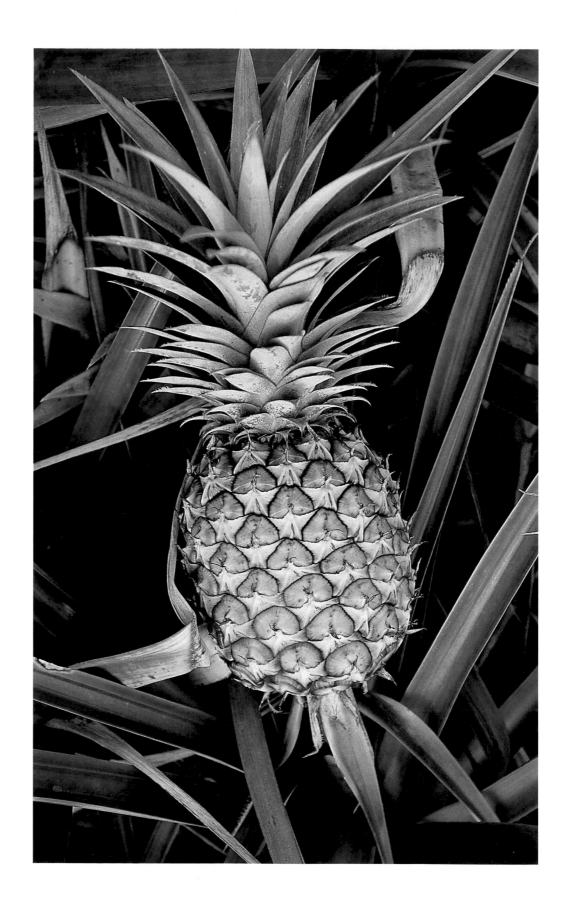

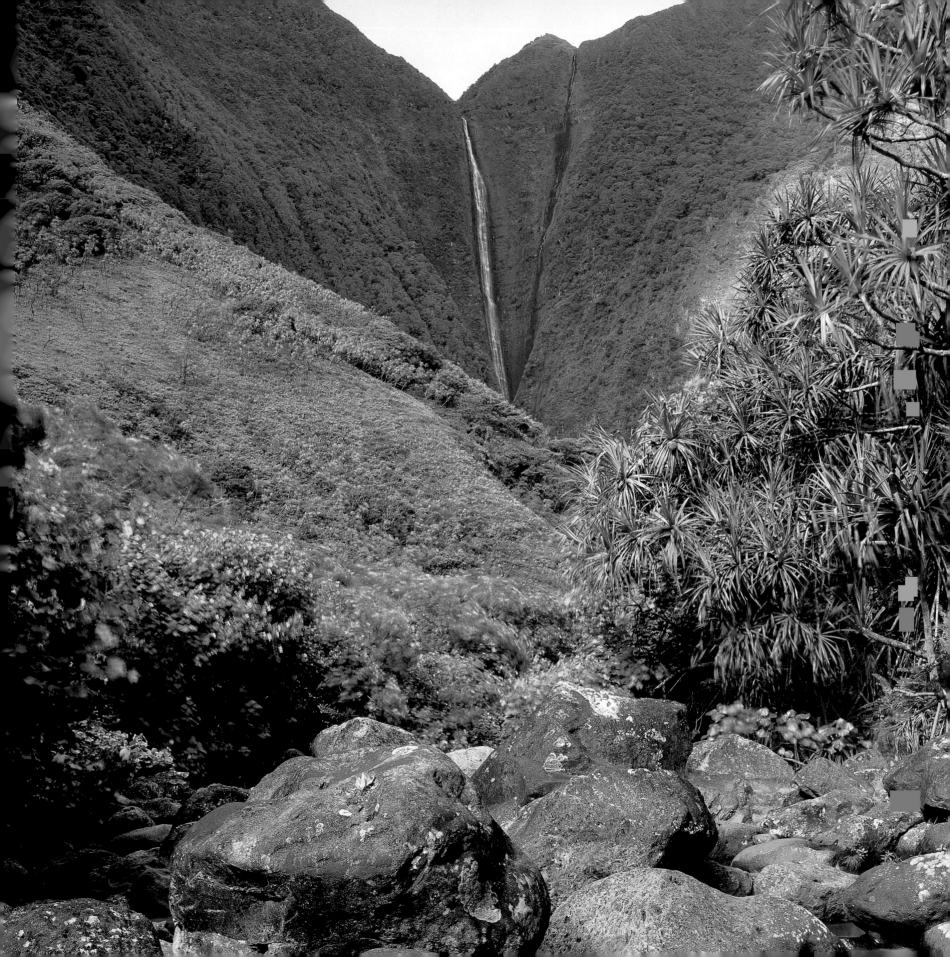

Rising more than 3,000 feet from the ocean waters, the sea cliffs of Molokai are the tallest in the world. Centuries ago, Hawaiians lived in the shallow valleys between these cliffs, irrigating their taro crops by diverting water from the abundant waterfalls.

FACING PAGE—
Once owned by Molokai Ranch, the 5,714-acre Pelekunu Preserve was bought by the Nature Conservancy in 1987. Remote and inaccessible to the public, the region includes towering sea cliffs, one of Hawaii's last untouched streams, and luxuriant rainforest.

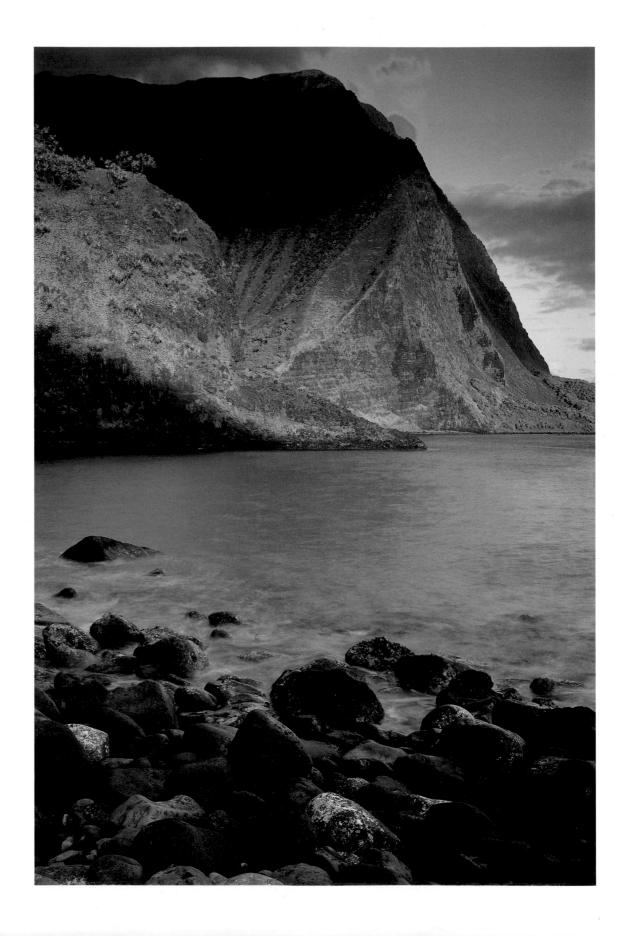

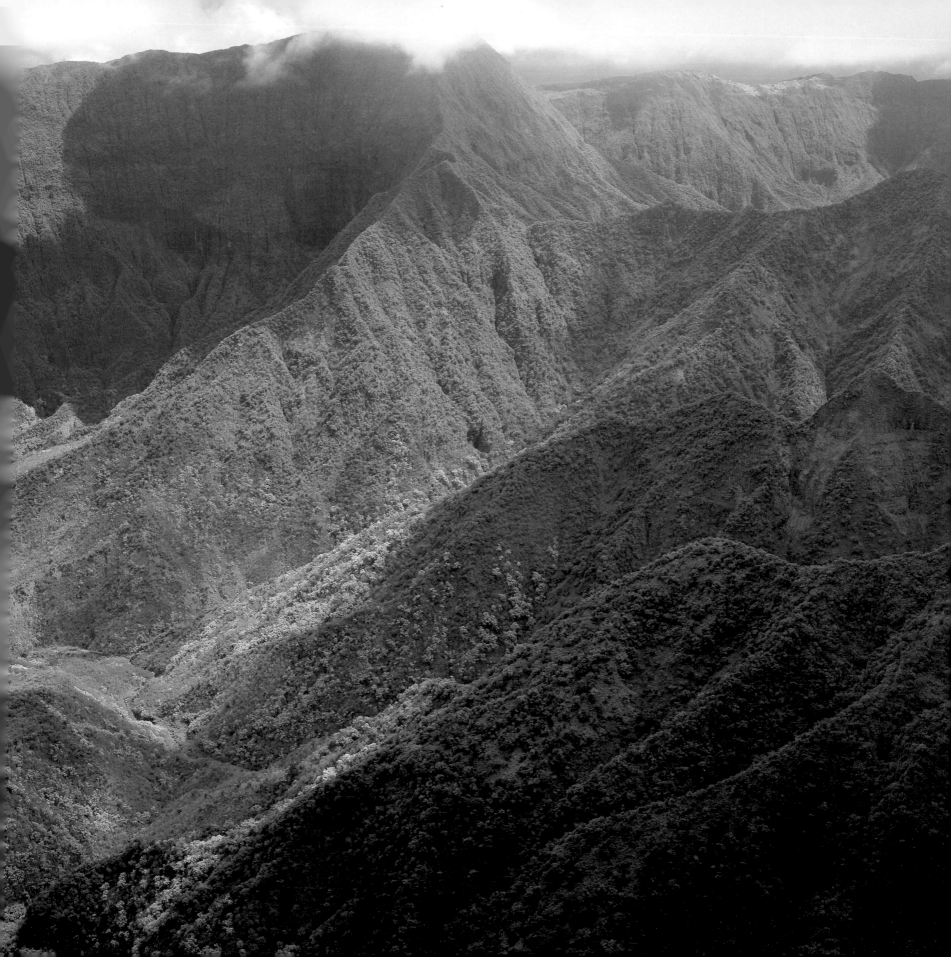

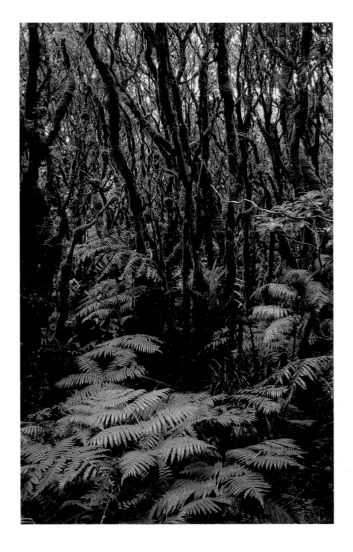

Kamakou Preserve embraces 2,774 acres of primitive rainforest atop one of Molokai's volcanic mountains. More than 200 of the plant species that flourish here are found nowhere else on earth.

As King Kamehameha I fought to unite the islands in the late 1700s, hundreds of warriors arrived by canoe on the shores of Molokai. At the Pukuhiwa Battleground, sling-shot stones, still piled and ready for use, have been found by archaeologists.

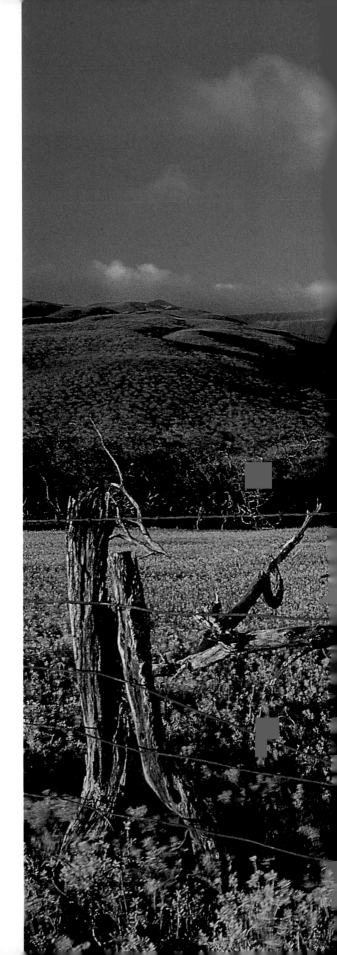

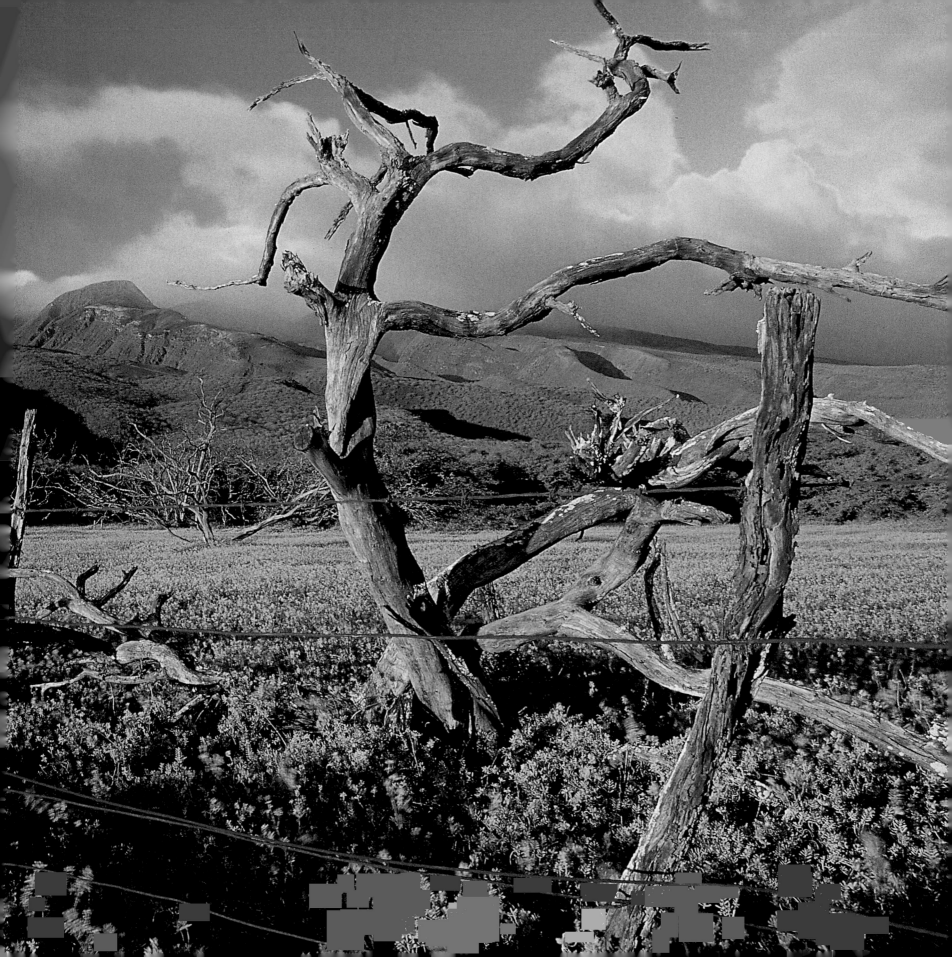

Six hundred people with Hansen's disease, or leprosy, were quarantined on the island of Molokai in the late 1800s. A Belgian priest, Father Damien de Veuster, ministered to the residents until succumbing to leprosy himself in 1889. The peninsula is now protected by Kalaupapa National Historic Park.

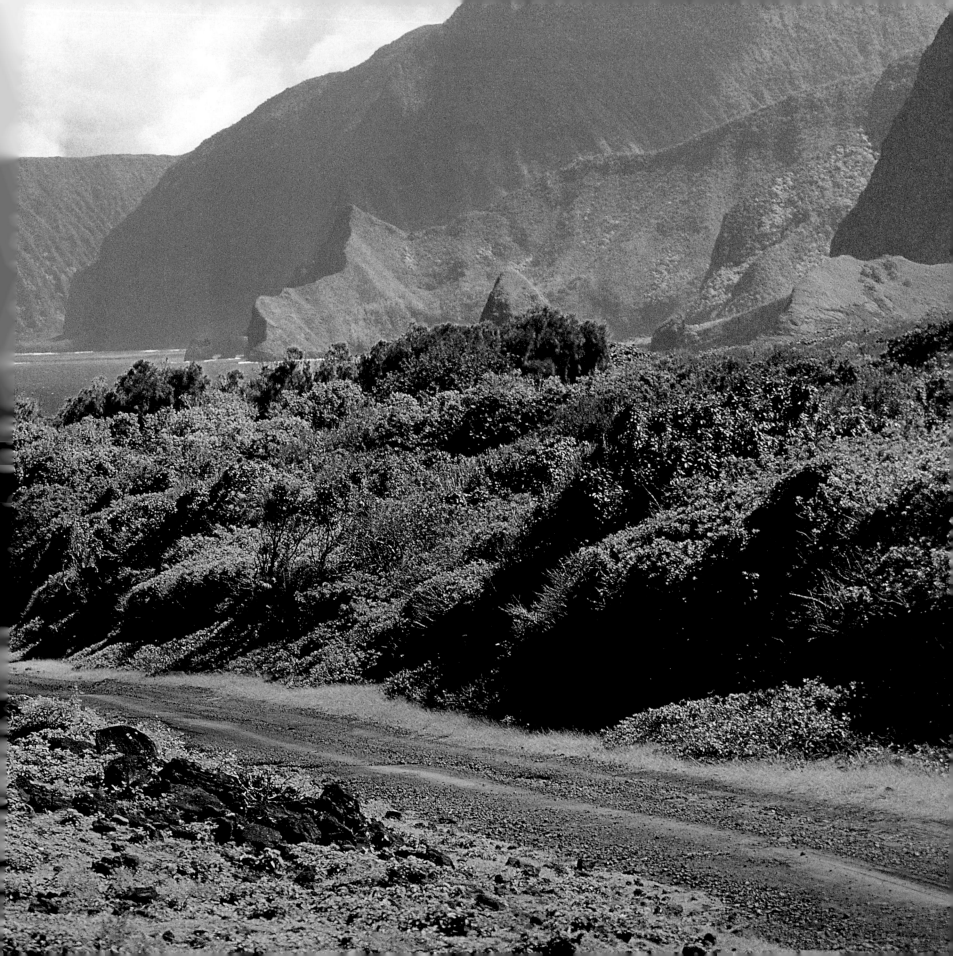

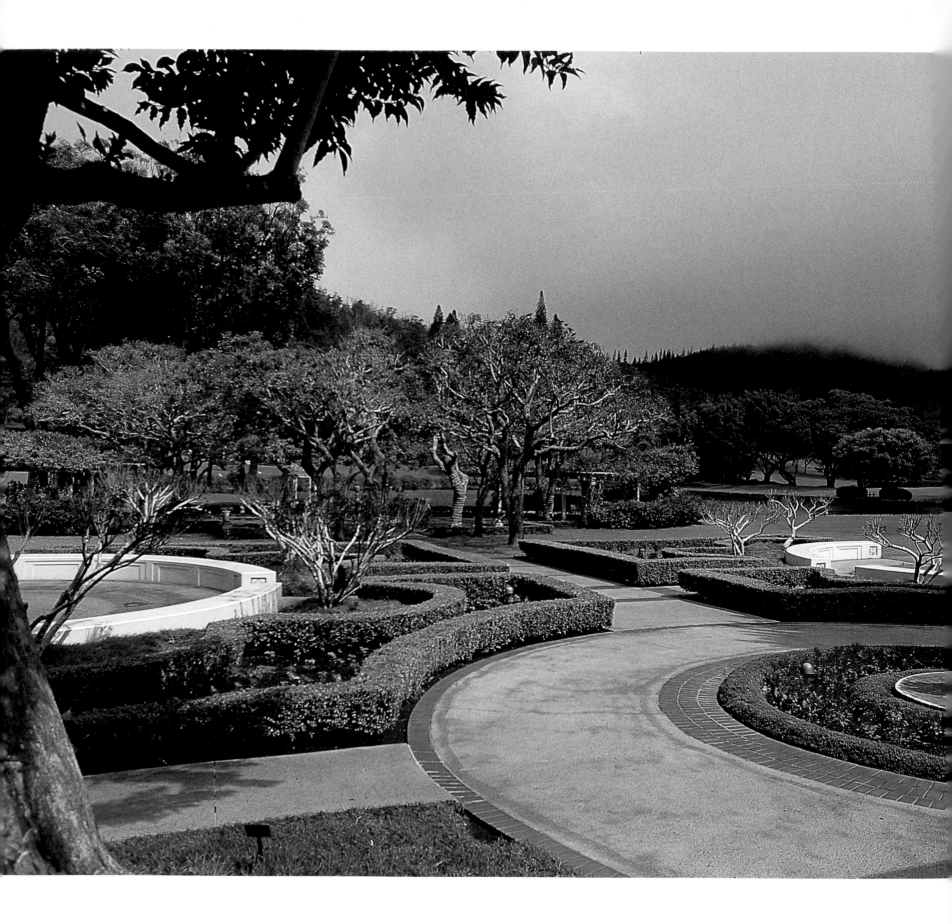

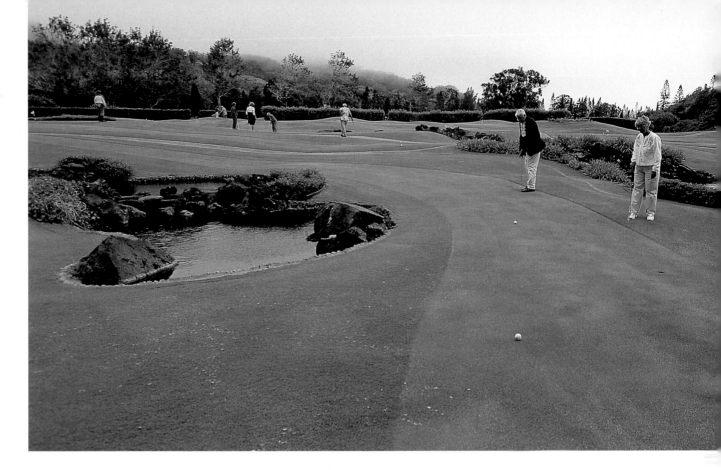

With only 25 miles of paved roads and no traffic lights, the island of Lanai provides a tranquil escape. Many of the island's visitors are golfers, who arrive to test their skills on The Experience at Koele course or The Challenge at Manele, which leads enthusiasts along the sea cliffs over Hulopoe Bay.

FACING PAGE—
Much of Lanai was ranchland until 1922, when the Hawaiian Pineapple Company purchased most of the island. Using underground streams, the company irrigated some of the island's arid plains, making agriculture possible. Pictured here are the gardens at Koele Lodge.

OVERLEAF—
Ocean winds and rare rainfall have kept Lanai's Garden of the Gods free of topsoil and vegetation. The red earth and carved rock formations create an otherworldly landscape that was sacred to early Hawaiians; remnants of their shrines still remain.

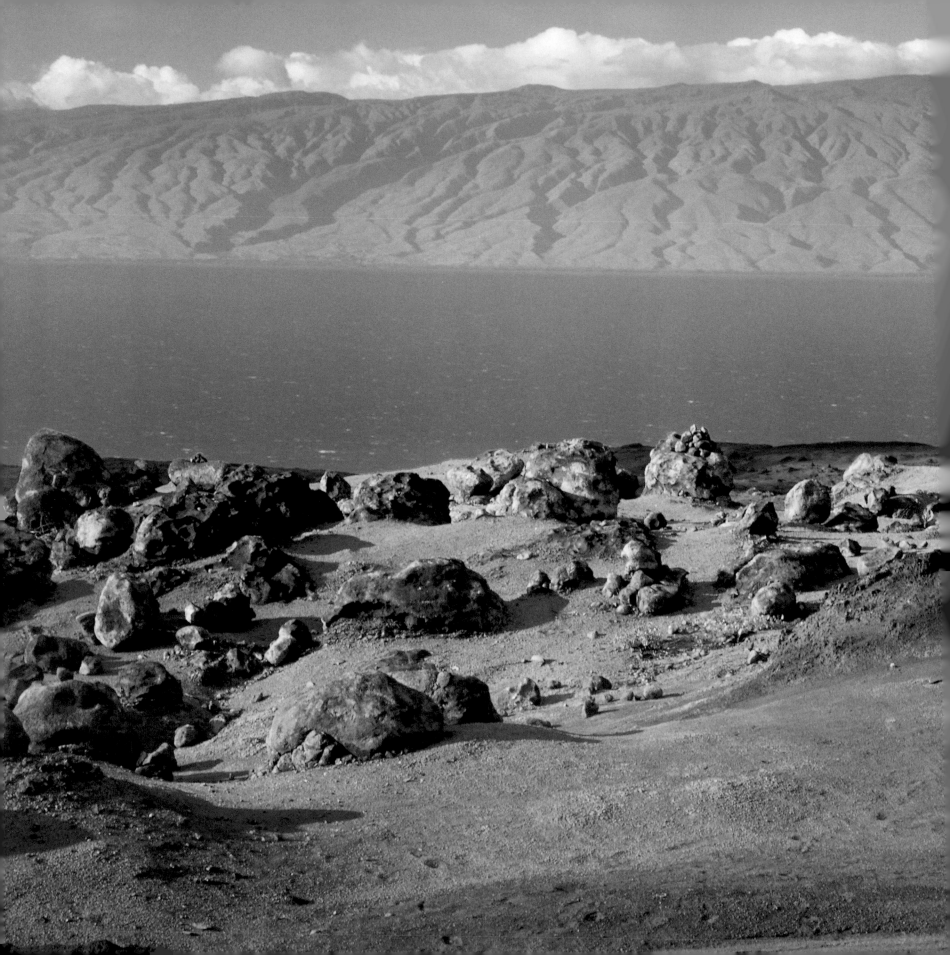

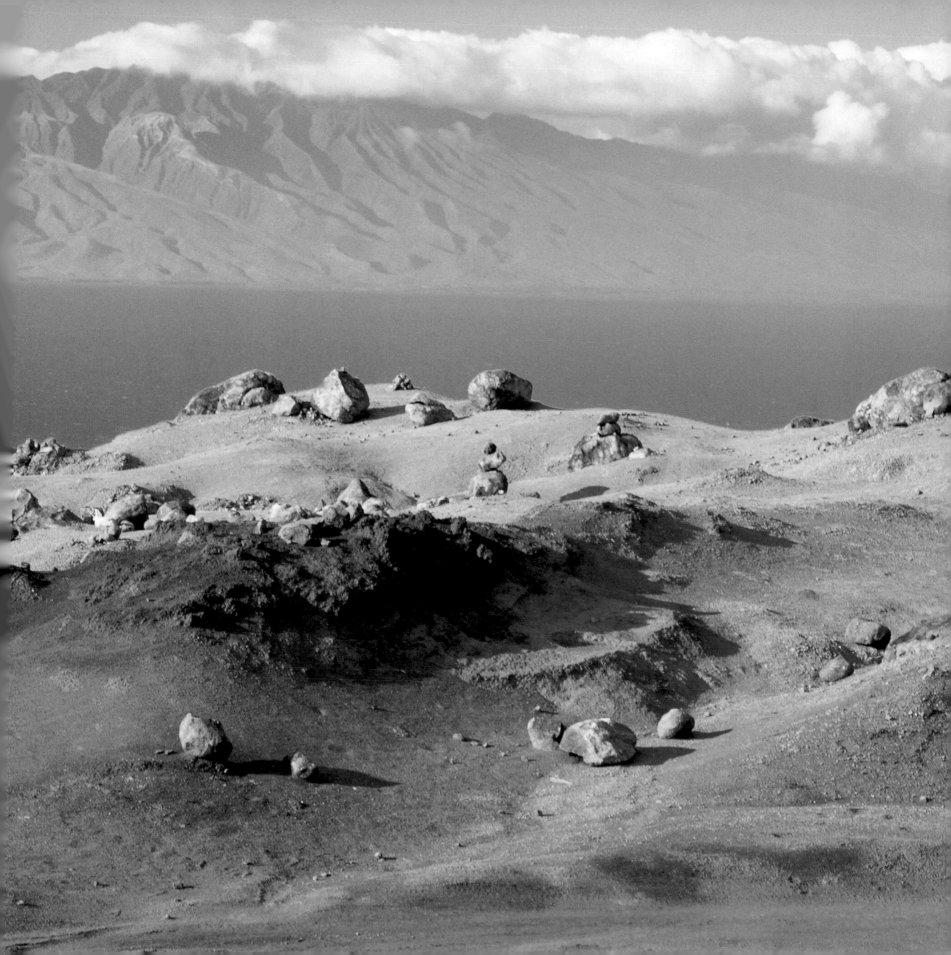

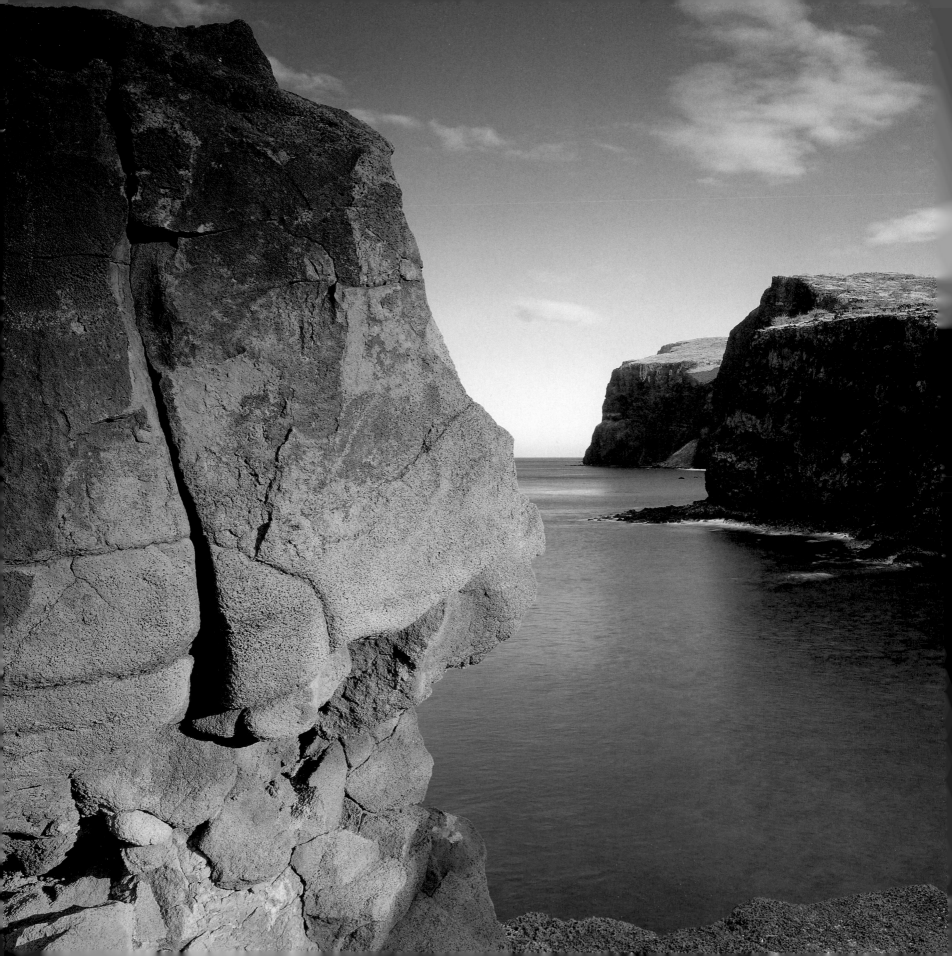

Frangipani was brought to the islands from Asia in the 1800s. Although Hawaiian botanists fight a constant battle against many non-native plants that threaten indigenous species, the easily contained frangipani has proved innocuous. Its fragrant flowers are often seen in Hawaiian leis.

FACING PAGE—
On the southern shores of Lanai stand the remains of the village of Kaunolu. A nearby temple served as a place of refuge for those who broke taboos. The rock structures here were once the summer retreat of King Kamehameha I and his household. This 60-foot cliff—Kahekili's Leap—allowed the king's warriors to test their bravery.

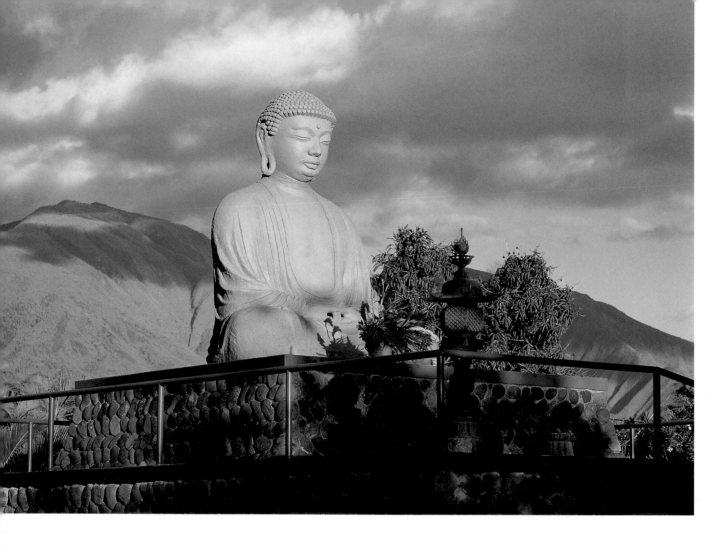

In 1968, a century after the first Japanese immigrants arrived
in Hawaii, supporters of the Lahaina Jodo Mission on Maui
completed the construction of a giant Buddha and a temple
bell, modelled after those on the other side of the Pacific.
The surrounding temple was completed two years later.

In the 1800s, Lahaina was the base of Maui's whaling indus-
try and the whalers lived a rough and rowdy onshore life
that shocked newly arrived missionaries. Today, humpbacks
still breach just offshore, hunted mainly by camera-toting
sightseers in whale-watching vessels.

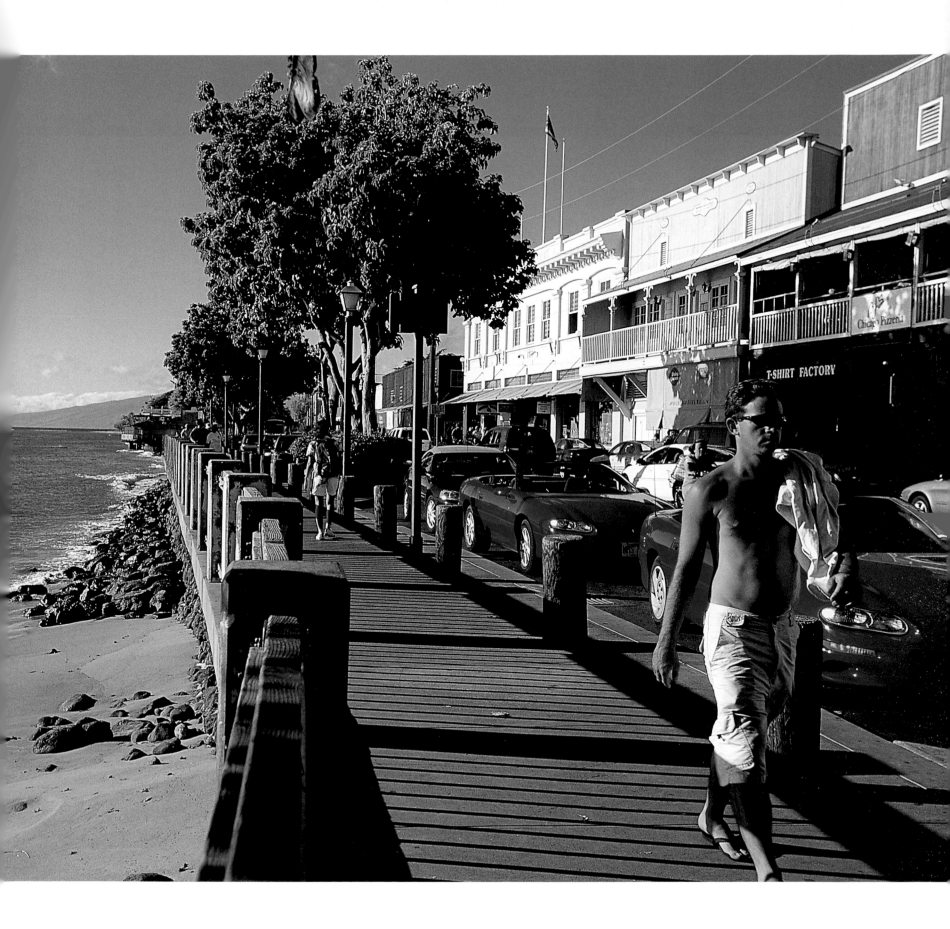

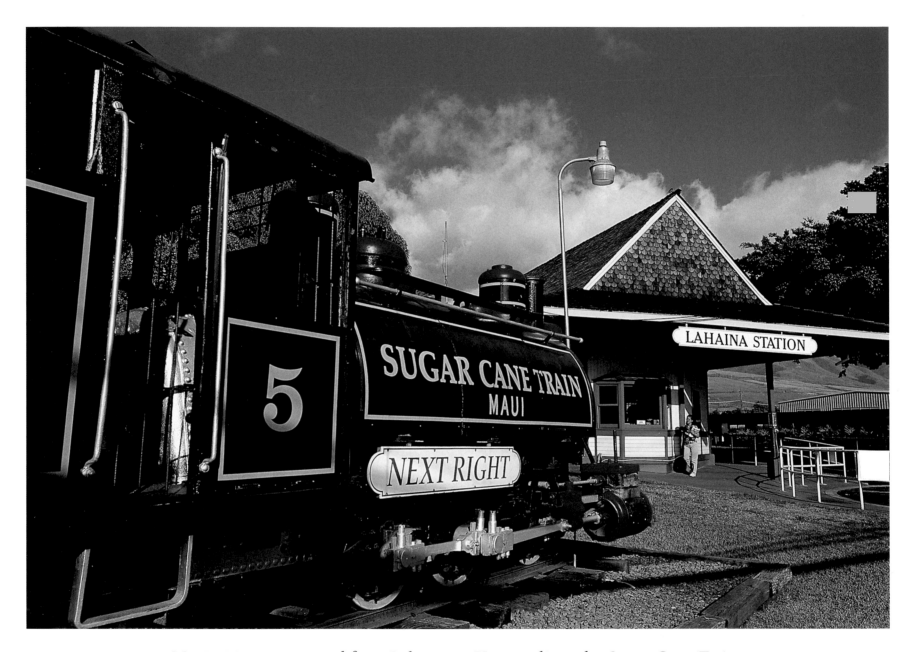

Maui visitors can travel from Lahaina to Kaanapali on the Sugar Cane Train, a reminder of the days when steam locomotives transported workers to the fields each morning and hauled the harvested canes to mills for processing. The highlight of the journey is a restored 415-foot-high wooden trestle.

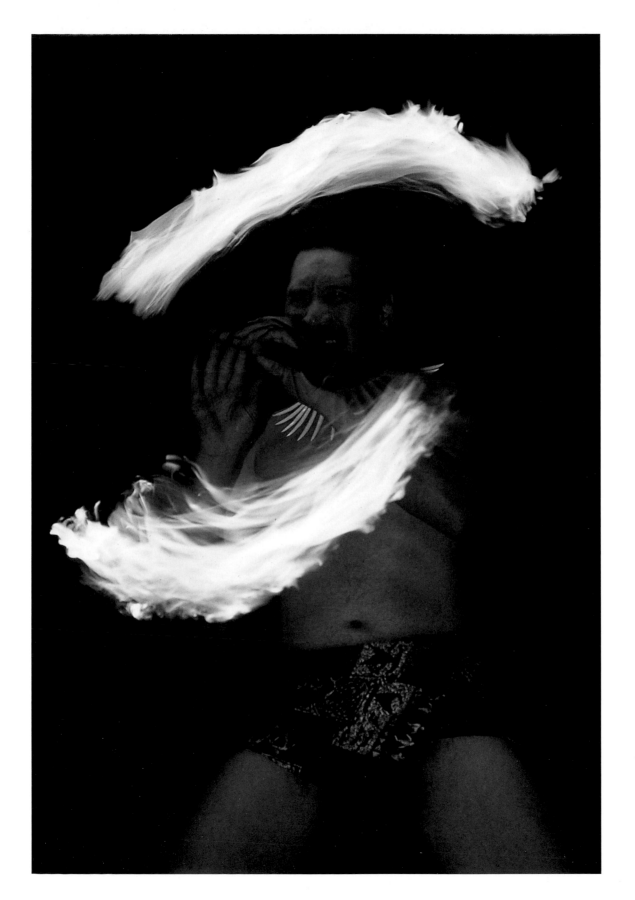

The luaus popular at many Maui hotels incorporate dances from several of the Polynesian islands. The Samoan Fire Knife Dance, which features a performer juggling and throwing flaming knives, is always a favorite to watch.

Hawaiians celebrated special occasions with luaus long before Europeans arrived. Traditionally, men and women would eat separately and were served different dishes. In some cases, women were not allowed to eat certain foods, such as bananas, coconuts, and turtle.

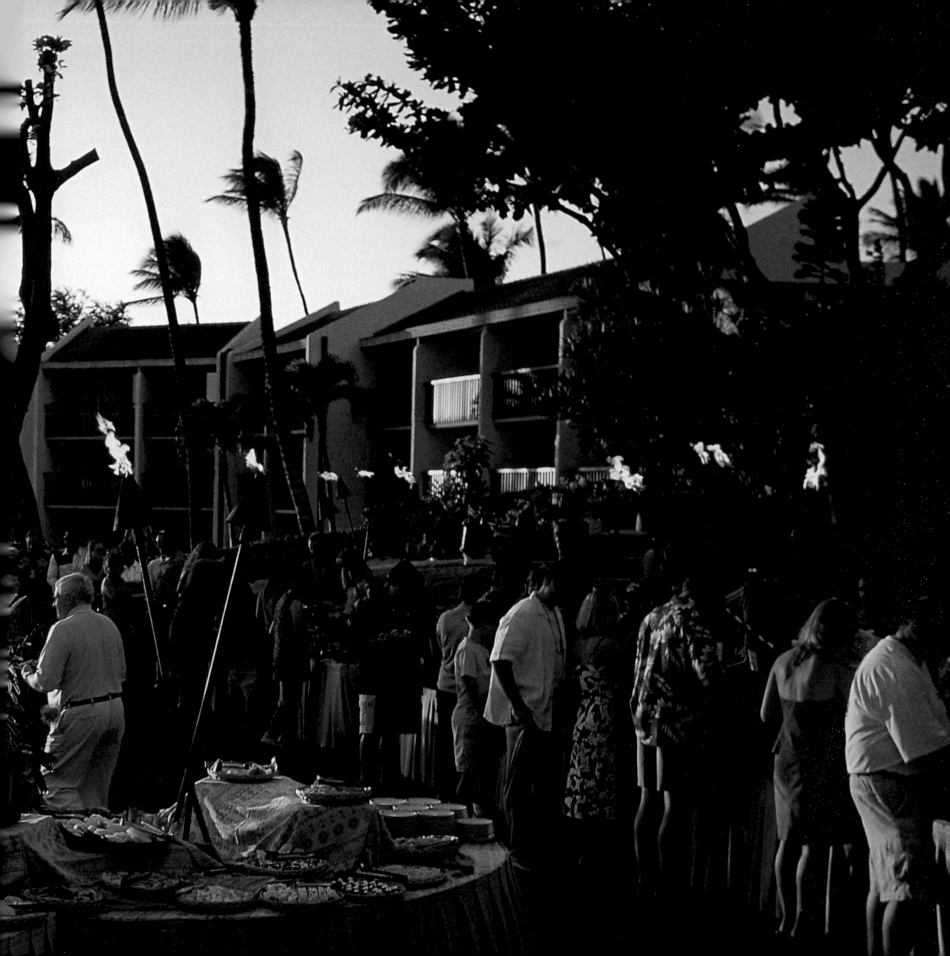

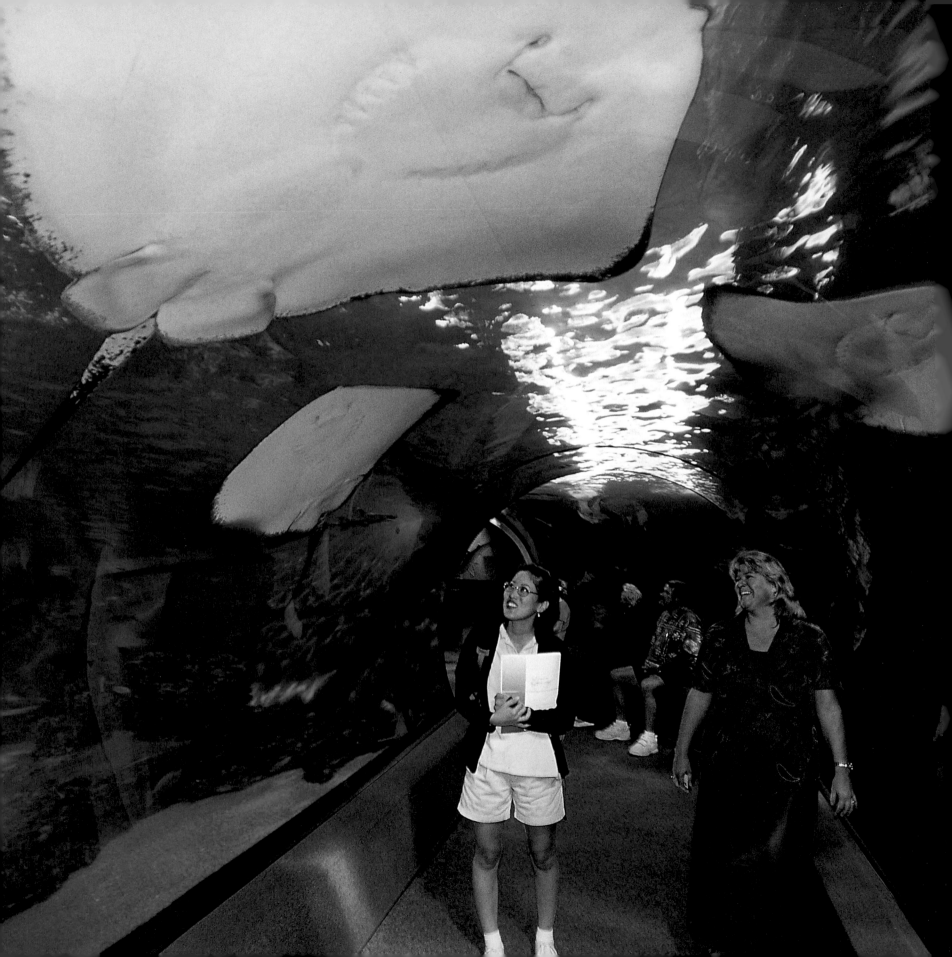

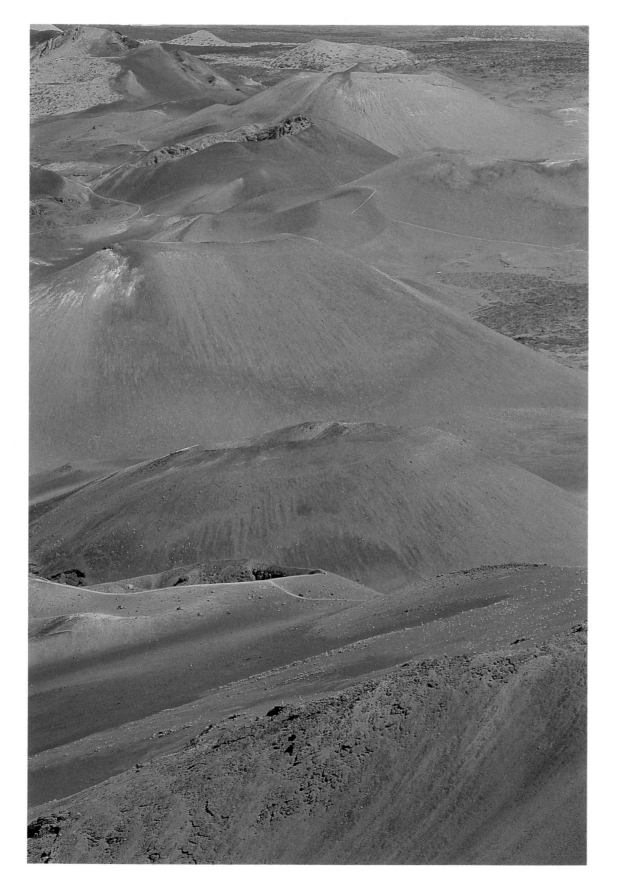

Haleakala is a dormant volcano more than 10,000 feet high. According to local myth, the god Maui hid atop Haleakala's summit and caught the sun as it sped across the sky. Maui broke some of the sun's legs, slowing its passage and granting the Hawaiians longer days.

FACING PAGE—
Featuring the largest tropical reef aquarium in North America, the Maui Ocean Center includes more than 60 interactive displays. Stingrays and young hammerhead sharks glide through a shallow cove, sea stars and urchins perch within reach of visitors, and green sea turtles paddle in a specially designed lagoon.

More than two-thirds of Haleakala National Park is wilderness, including this dense bamboo forest. More than 250 inches of annual rainfall helps to replenish the many streams and waterfalls.

FACING PAGE—
Sunset turns Ahihi Bay a brilliant pink. The bay is part of Ahihi-Kinau Natural Area Preserve, a state-regulated area designed to protect Maui's youngest reef. Shallow, clear water makes this a favorite spot for snorkeling.

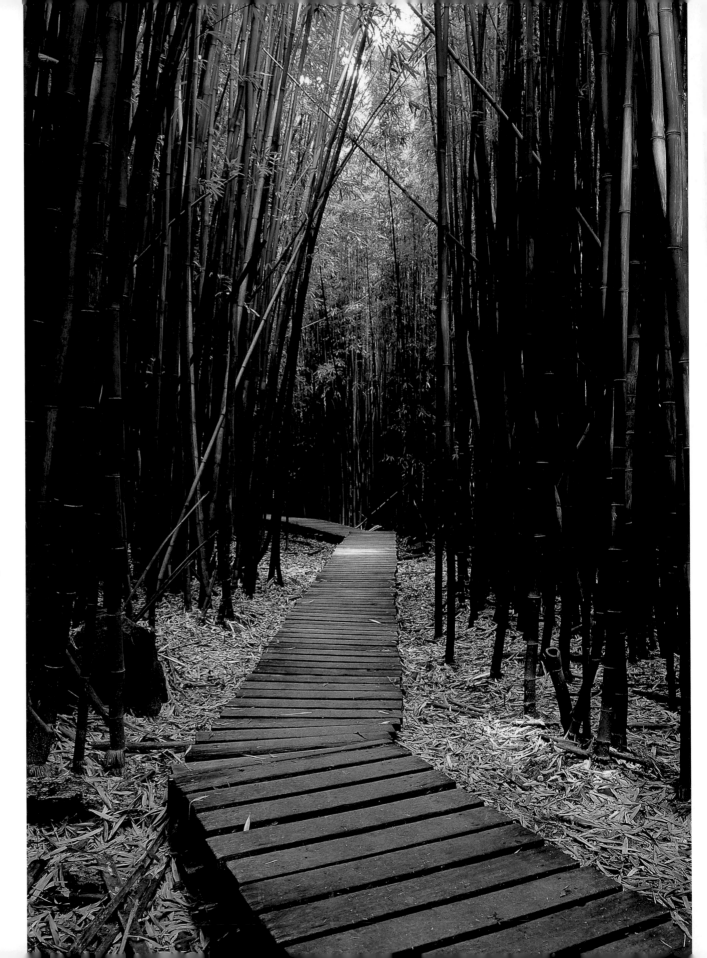

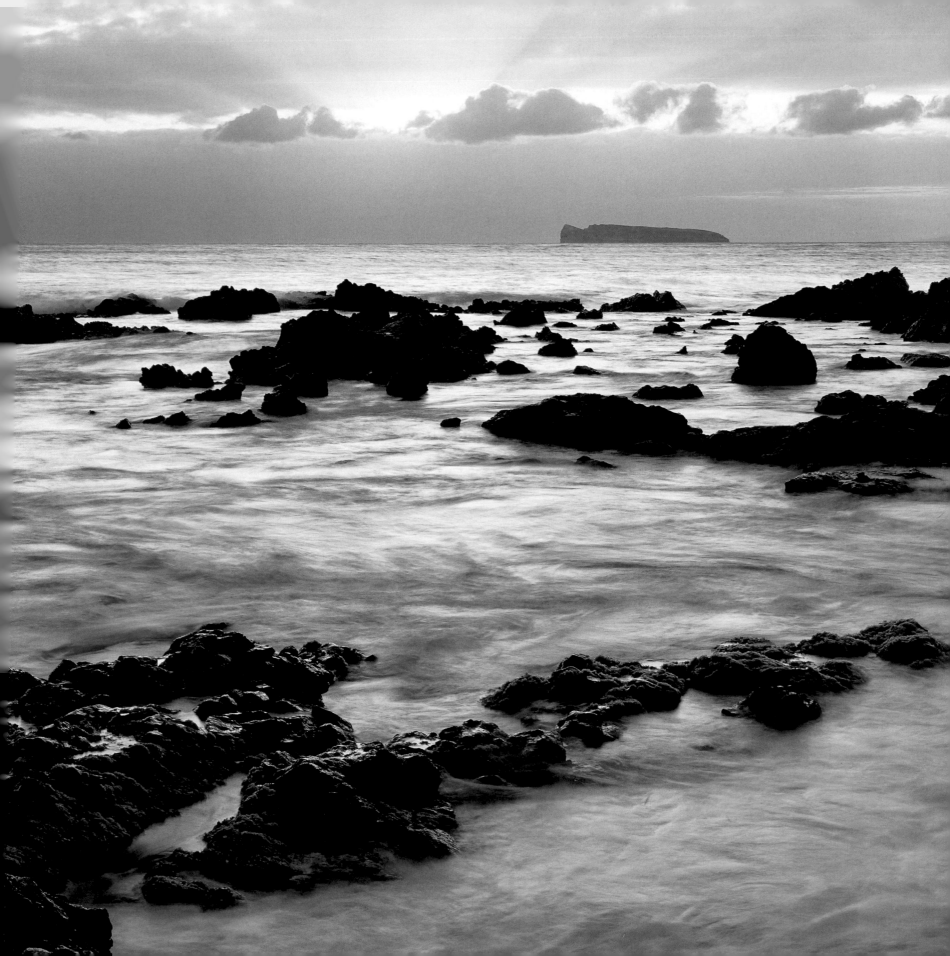

Along Maui's southern coast, Wailea is home to posh golf courses and luxury resorts. Beaches stretch along the shoreline, while calm waters and shallow coral reefs beckon swimmers and divers.

FACING PAGE—
Ho'okipa Beach Park on Maui's north shore offers swells perfect for surfing and windsurfing year-round. The experts, however, arrive in winter, when the waves reach heights of 20 feet. Visitors often gather along the beach to watch local competitions.

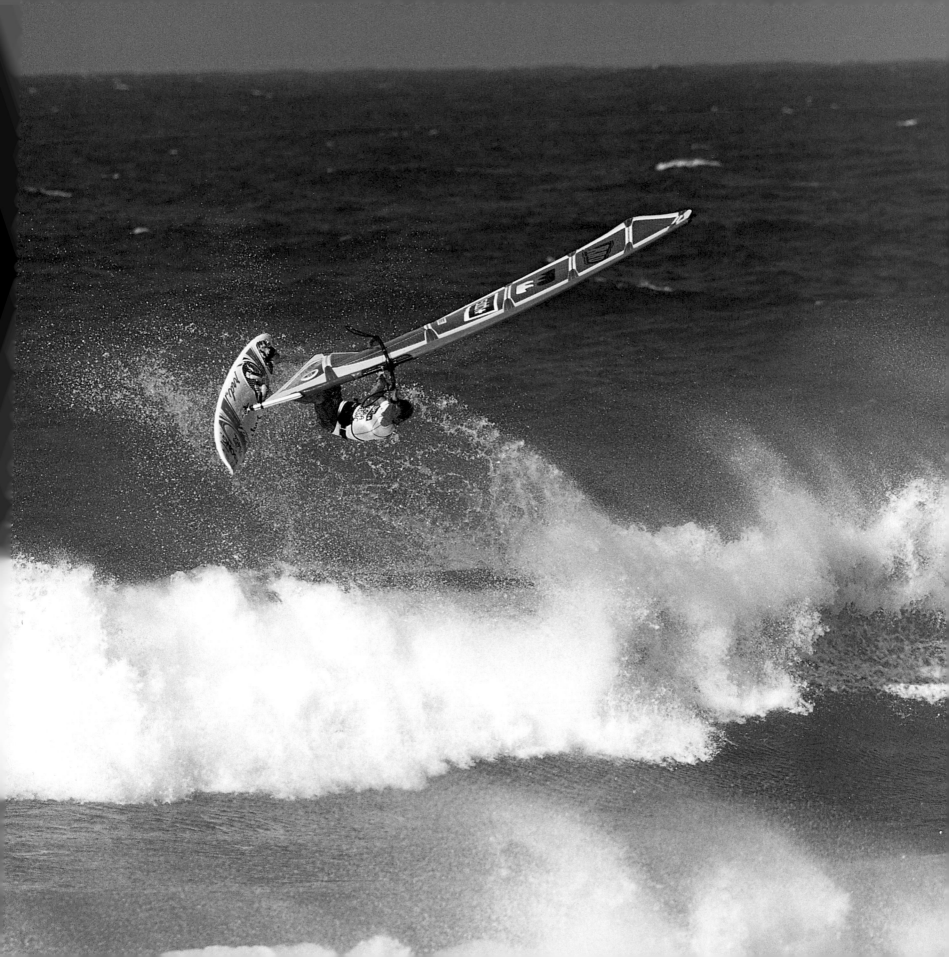

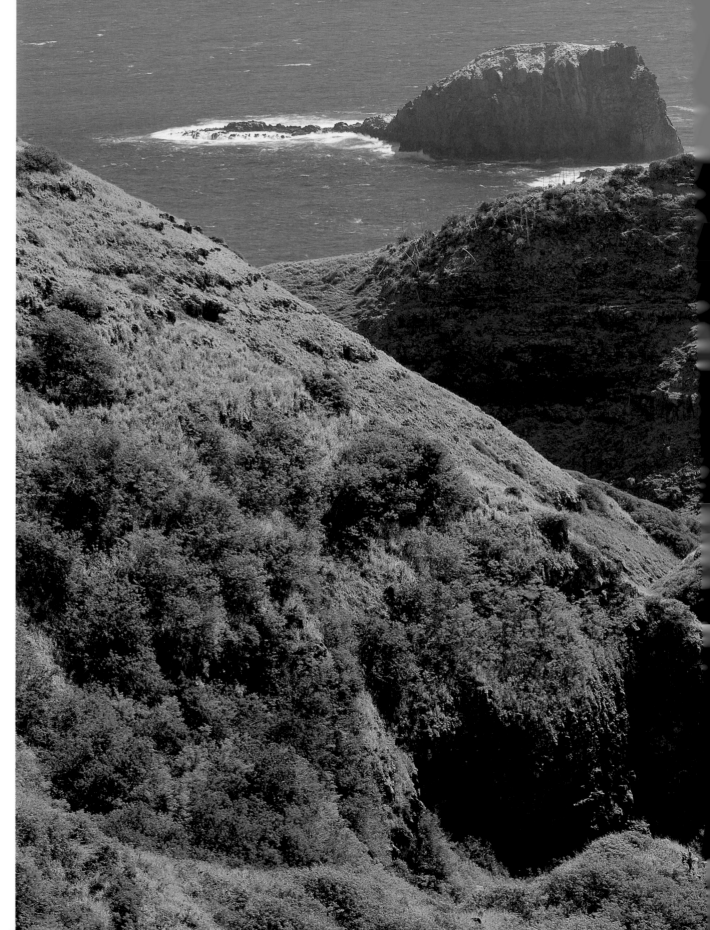

For thousands of years, life in Hawaii developed in isolation. Plants, insects, and birds evolved into species entirely different from those on the mainland. Until the Polynesians arrived with small pigs, bats and monk seals were the only mammals on the islands.

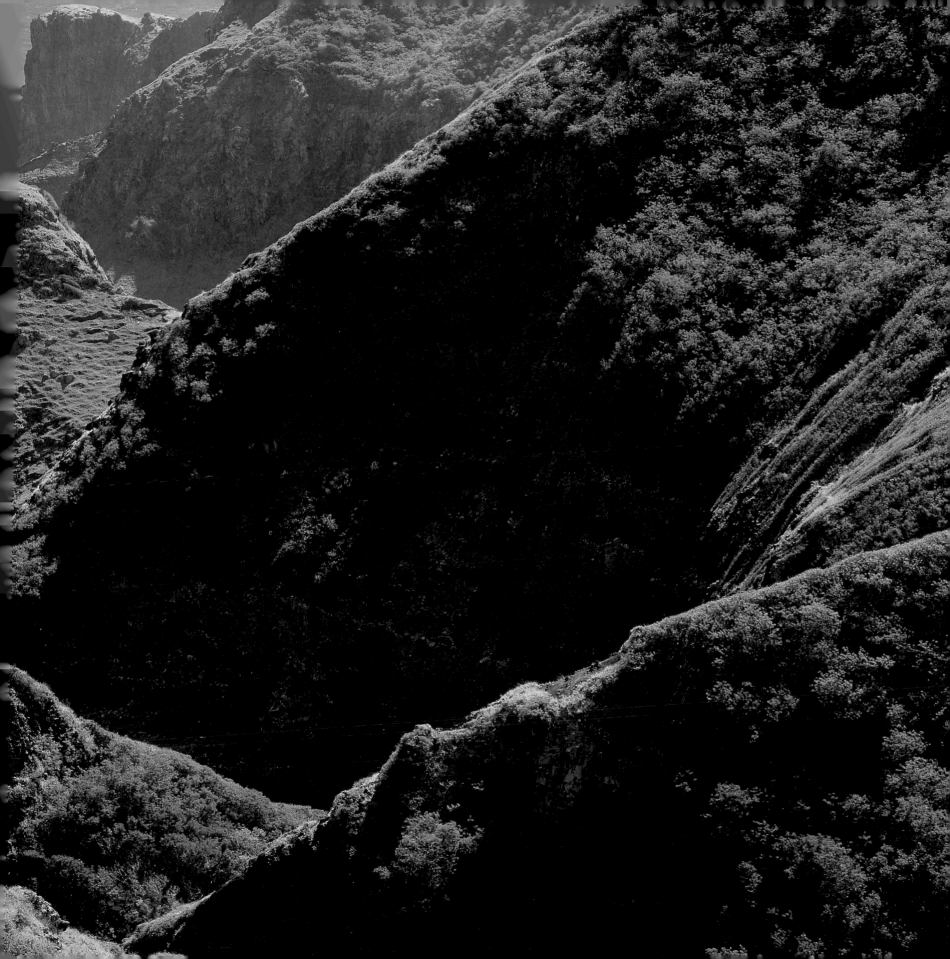

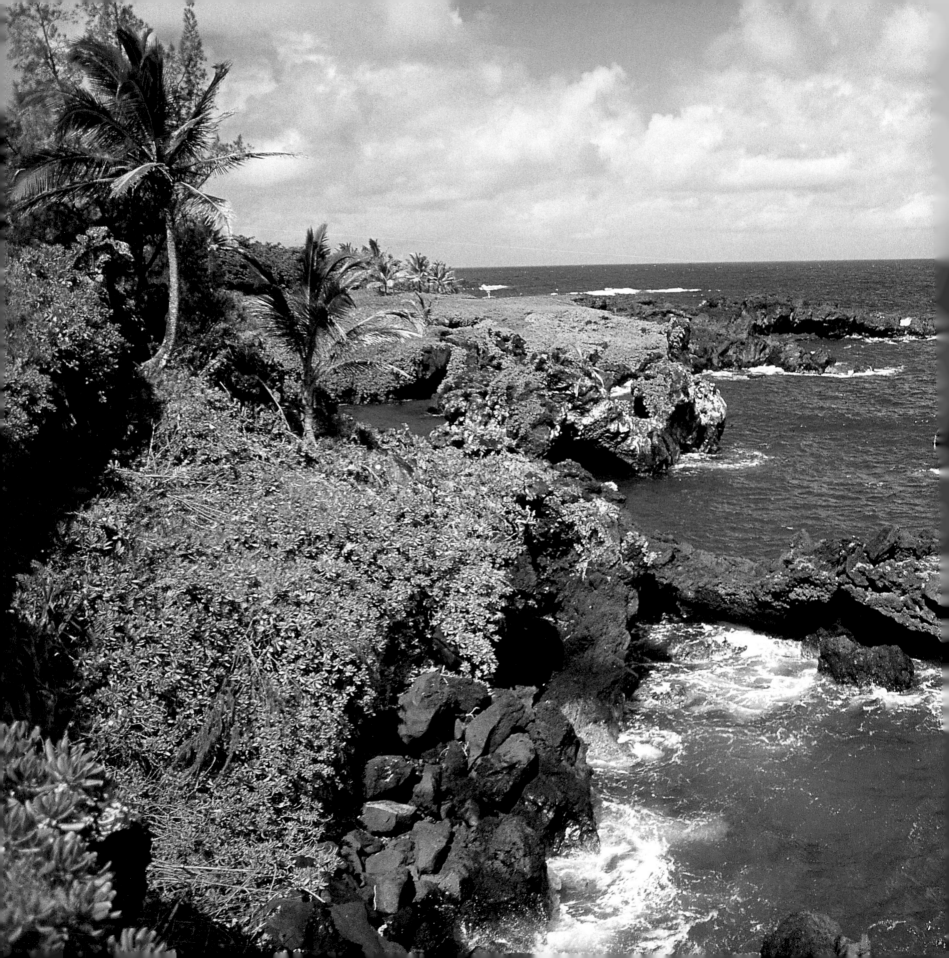

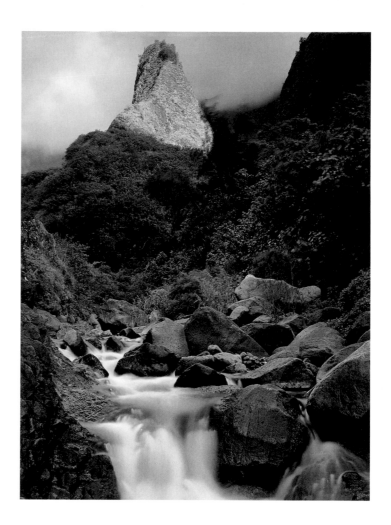

The warriors of King Kamehameha I fought in the shadow of the 1,200-foot Iao Needle, defeating the chief of Maui in a battle so fierce that the valley stream was said to run red with blood. Today, the sharp peak is protected by six-acre Iao Valley State Park and the basin is a gentler place, home to a botanical garden.

For visitors willing to explore an often single-lane 52-mile road with more than 600 curves and 56 bridges, Maui's Road to Hana offers plentiful rewards. There are spectacular ocean views, bamboo forests and banana groves, historic sites (including the grave of aviator Charles Lindbergh), and countless waterfalls.

Maui's Waianapanapa State Park offers more than sunshine and waves. Trails alongside the black sand beach lead to nearby lava tubes—tunnels formed of molten rock—as well as a native forest and the ruins of a historic worship site.

Facing Page—
Mauna Kea on the Big Island of Hawaii rises 13,796 feet above sea level, so high that the summit is above 40 percent of the atmosphere. Eleven powerful telescopes allow scientists to take advantage of the dry, thin air. In fact, their combined power is 50 times greater than that of the famous Hubble Space Telescope. This is the largest astronomical observatory in the world.

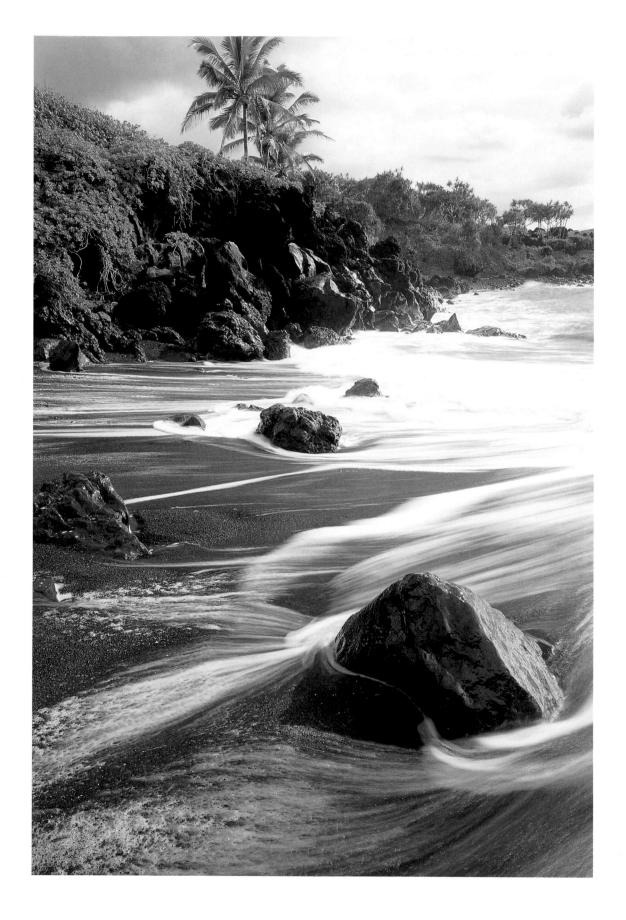

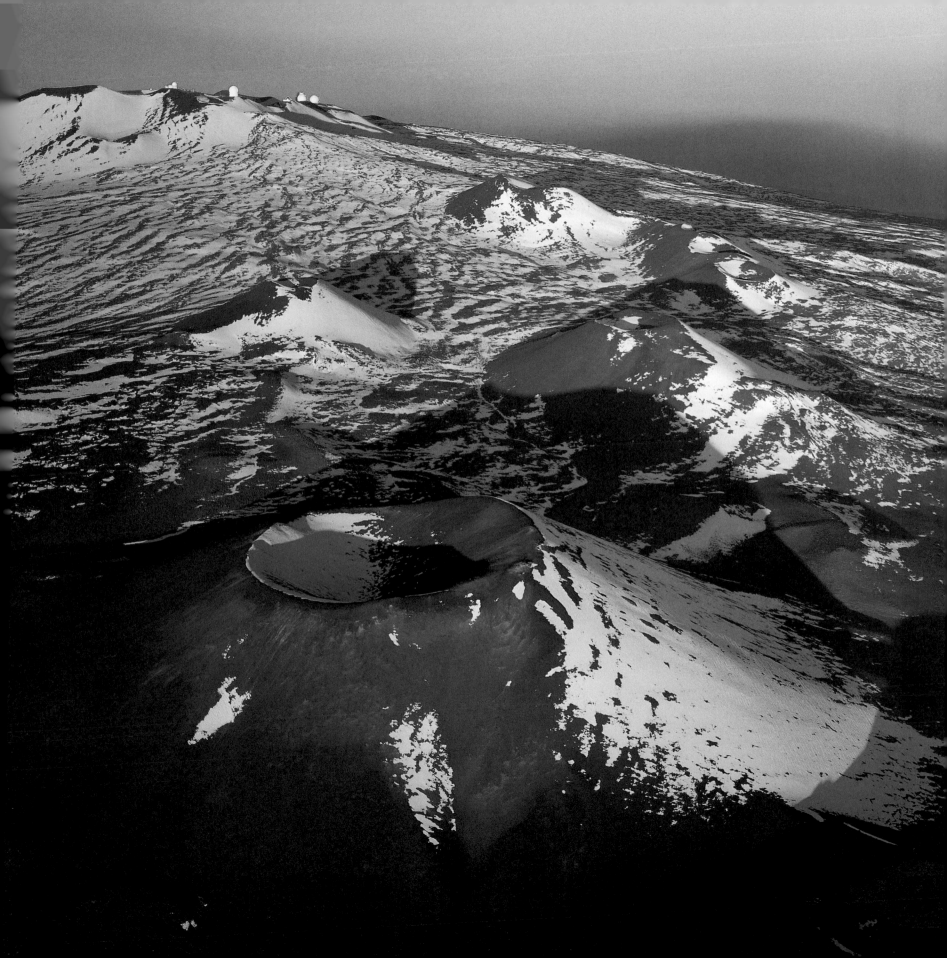

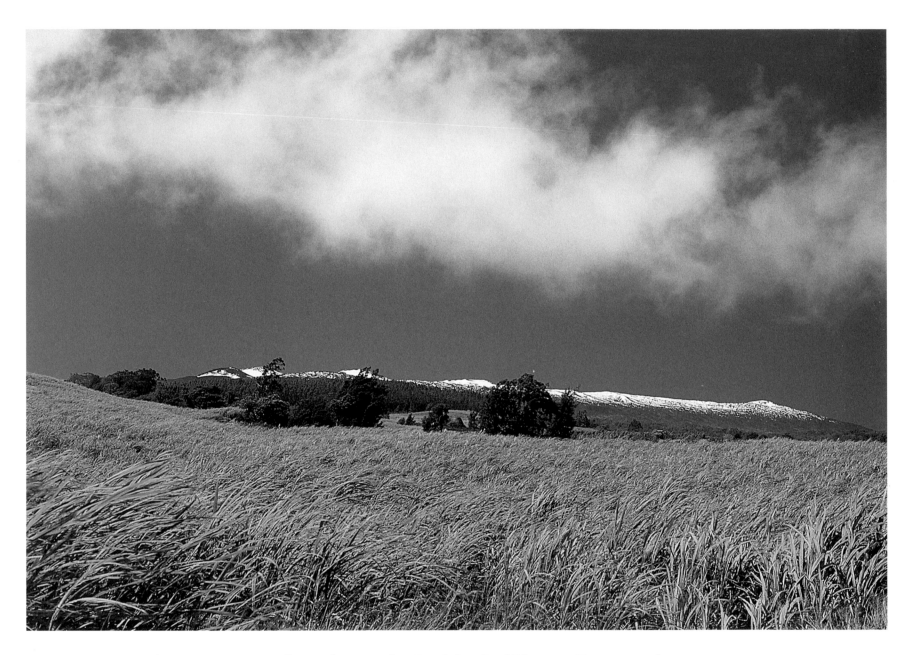

A sugarcane crop flourishes on the Big Island of Hawaii. For more than a century after the first commercial crop was planted in 1835, agriculture—sugar production in particular—was the mainstay of Hawaii's economy. In the mid-1900s, farms produced a million tons of sugarcane each year.

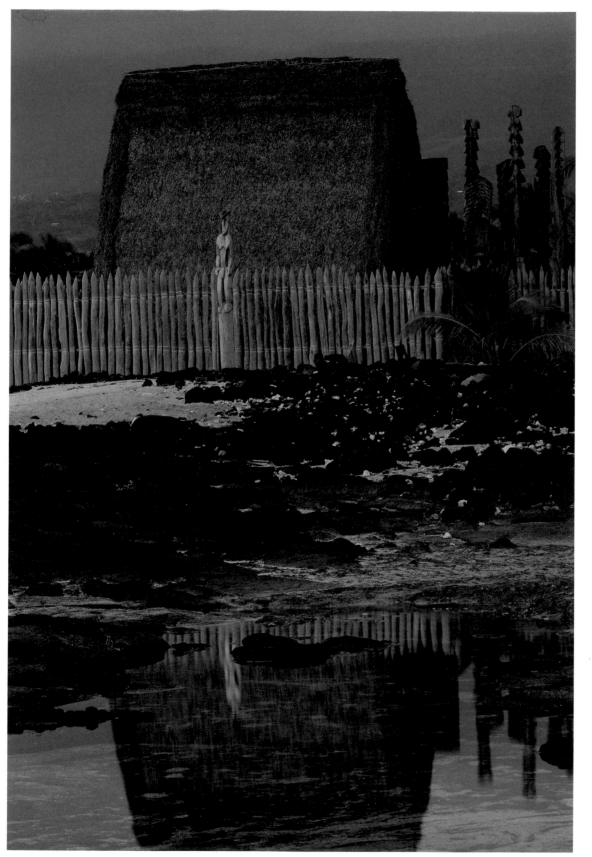

Pu'uhonua o Honaunau National Historic Park, also called the City of Refuge, offered shelter in ancient times to those who broke a *kapu*, or a rule of the gods. By retreating here, the offender could be absolved by a priest and thus avoid the punishment of death. Along with the refuge, the park protects the remains of several smaller temples, royal fishponds, and village sites.

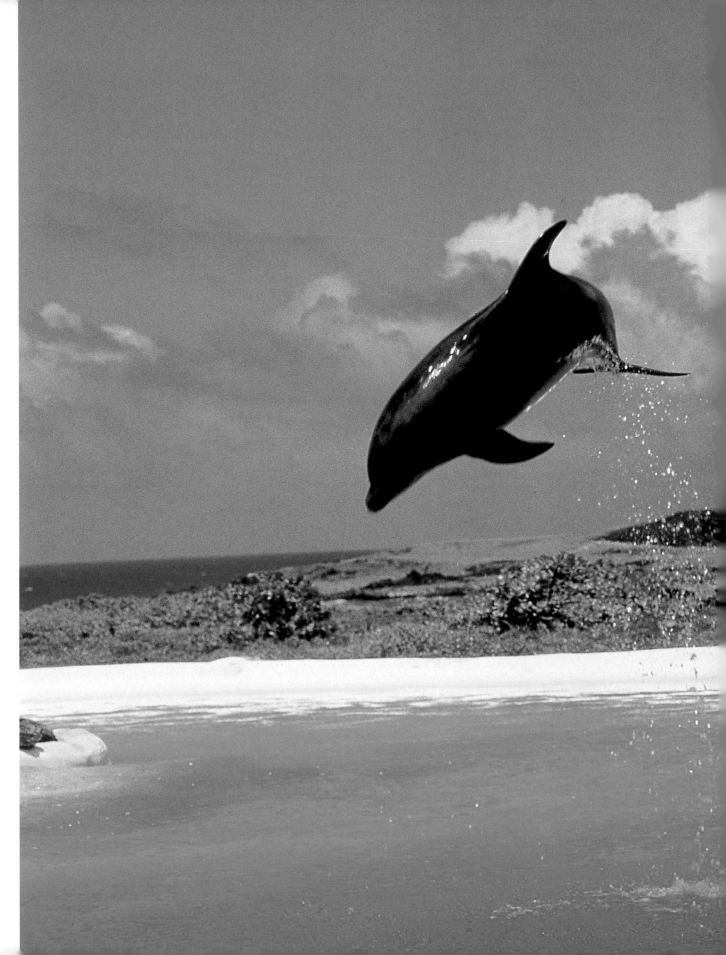

More than 15 dolphin species frequent the waters of Hawaii. Spinner and bottlenose dolphins, the most common, are sometimes seen in shallow coves close to shore. Their acrobatics include vertical leaps of up to six feet, tail slaps, and spins—as many as seven in a row in a single leap from the water.

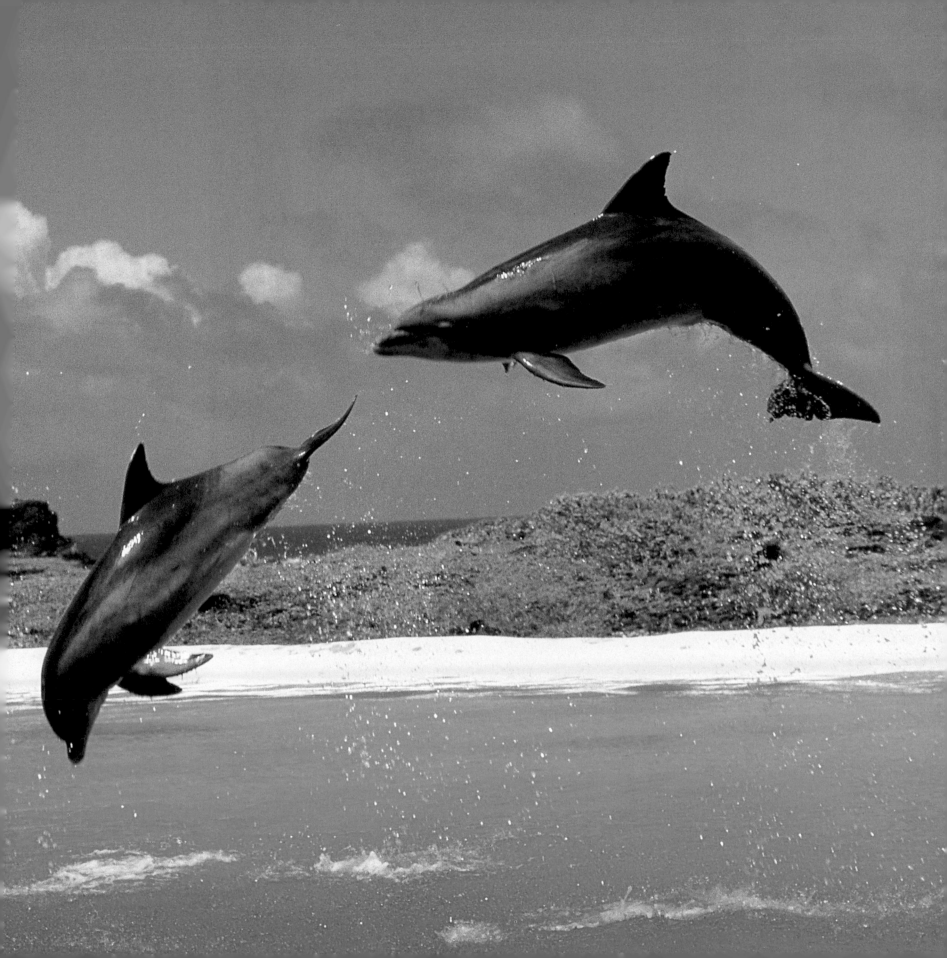

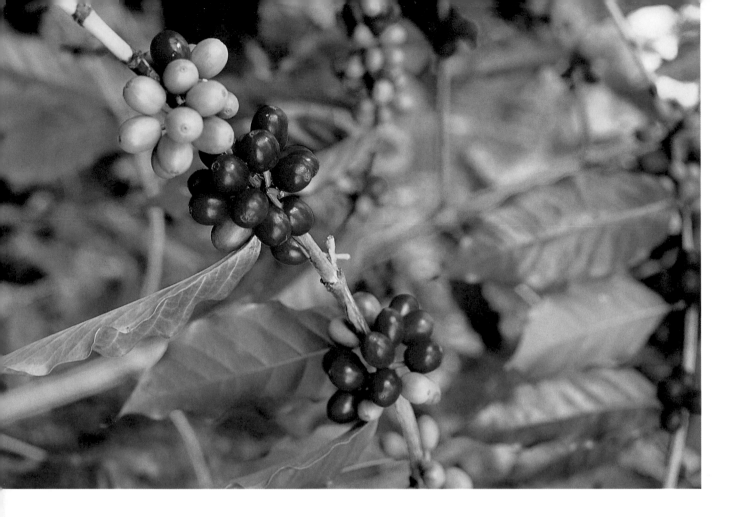

There are about 650 coffee farms on the Big Island, most near Kona. The first coffee trees in Hawaii were planted on Oahu in the early 1800s. Within a few decades, growers had discovered the rich volcanic soil of Kona, and commercial planting was underway.

Hawaii Volcanoes National Park includes the world's most active volcano. Lava flows from Kilauea have destroyed a campground, a visitor center, and several park roads, along with hundreds of homes and structures outside park boundaries. These rivers of molten rock could cover an area the size of Washington D.C. in less than a week.

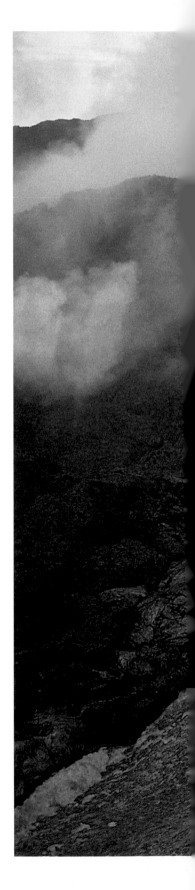

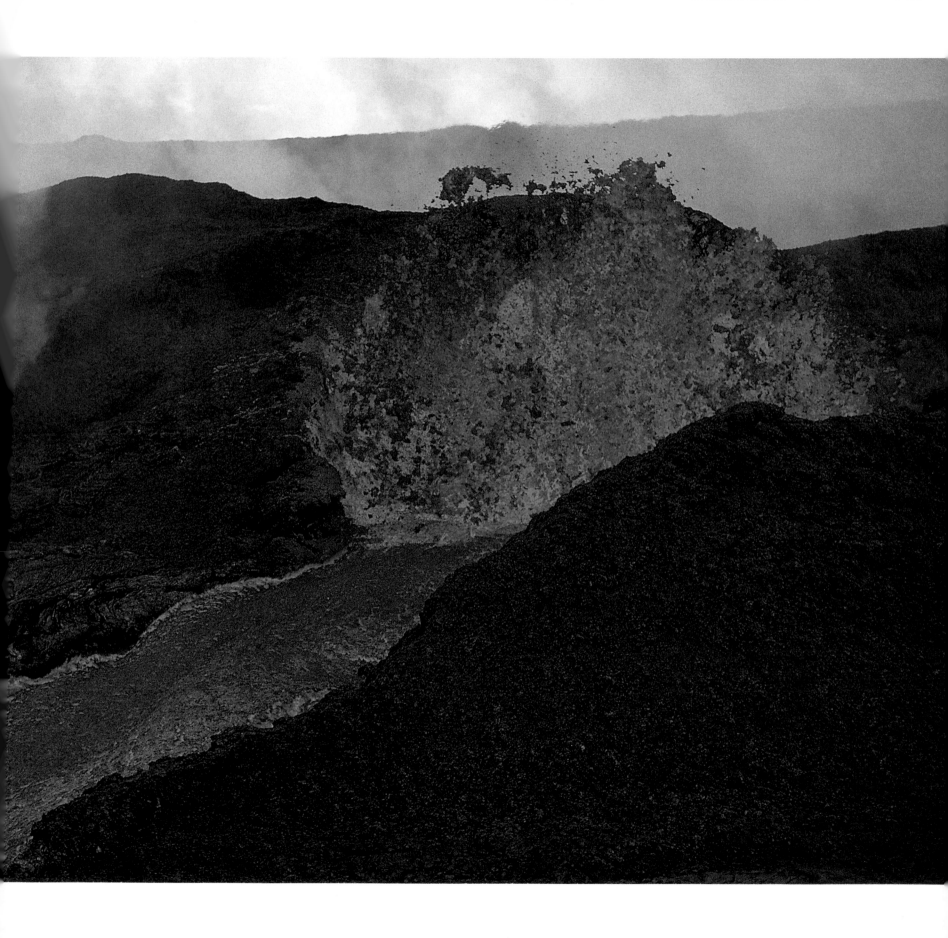

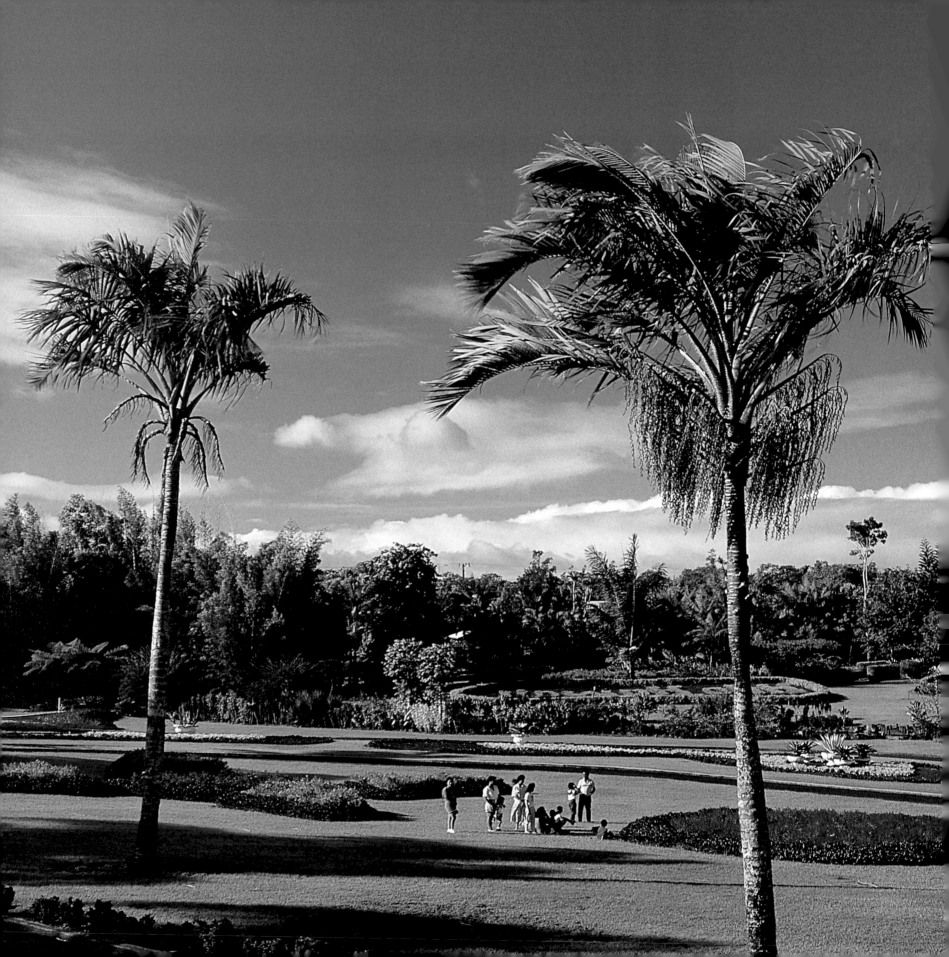

One of the rainiest cities in the United States, Hilo, on the east side of Hawaii, is known for its surrounding waterfalls and sumptuous greenery. Nani Mau Gardens includes 20 landscaped acres, abundant with tropical trees and flowers, cascading streams, and still pools.

After tsunamis in 1946 and 1960 destroyed much of Hilo, the waterfront was devoted to parks and gardens. One of these is Lili'uokalani Gardens, which features delicate Japanese bridges and stone lanterns. The gardens are named for Hawaii's last reigning queen.

OVERLEAF—
The steep sides of scenic Waipio Valley have helped protect it from development. In this "Valley of the Kings," where Kamehameha I is said to have received some of his royal training, families still live a traditional lifestyle. Taro fields, fishponds, and fruit trees border the shore.

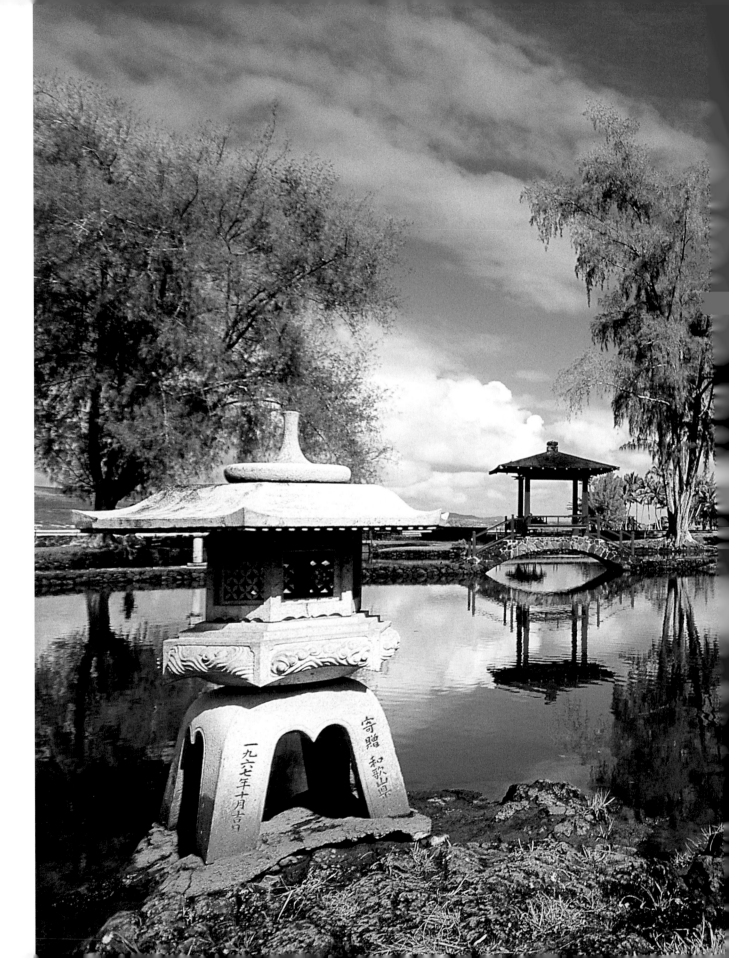

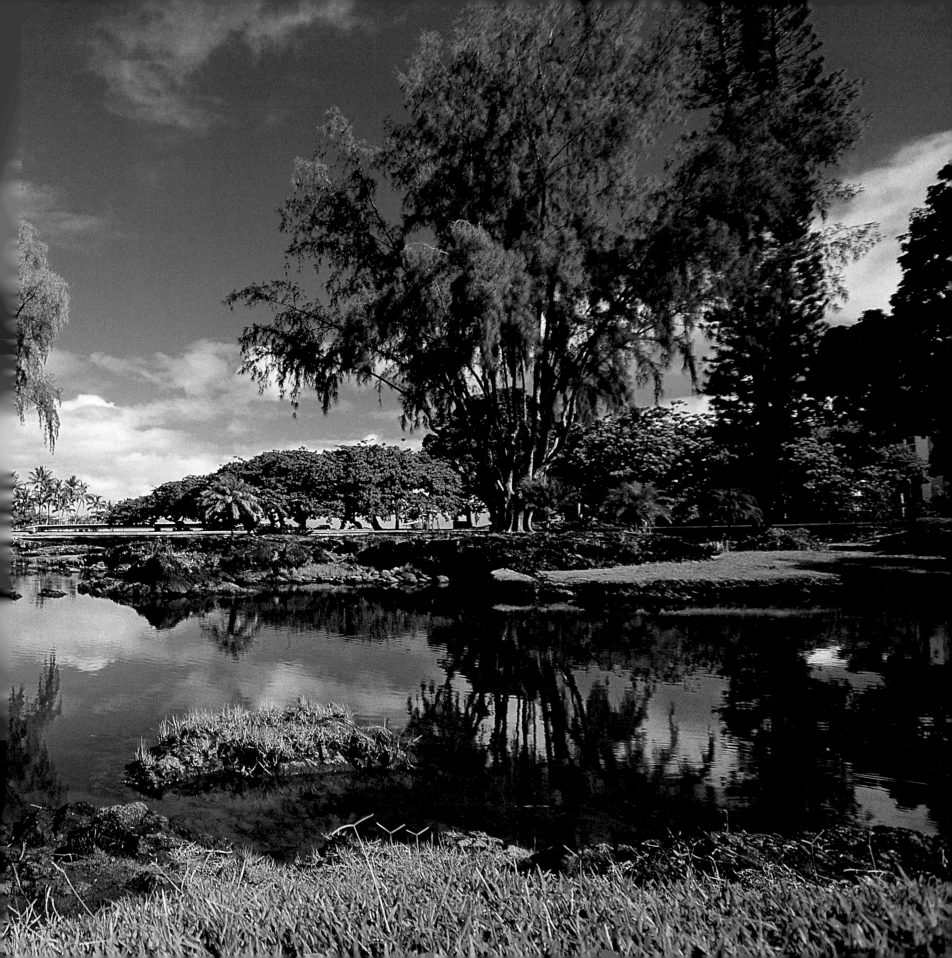

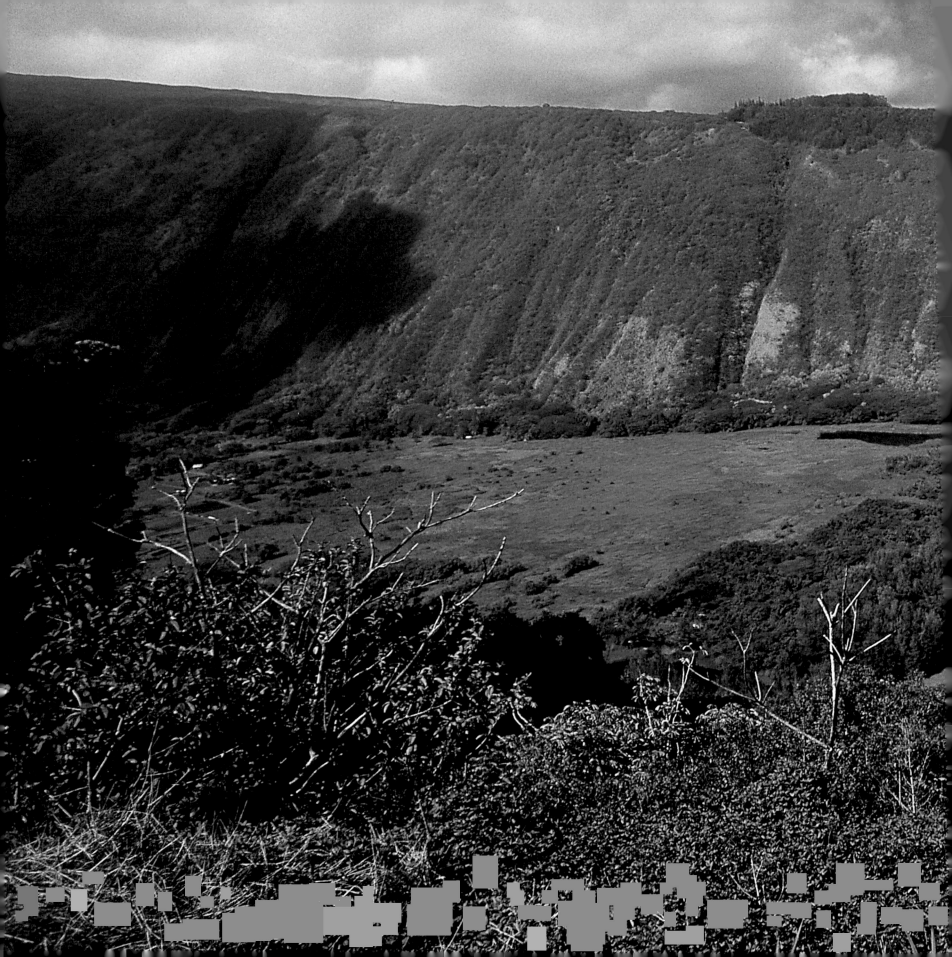

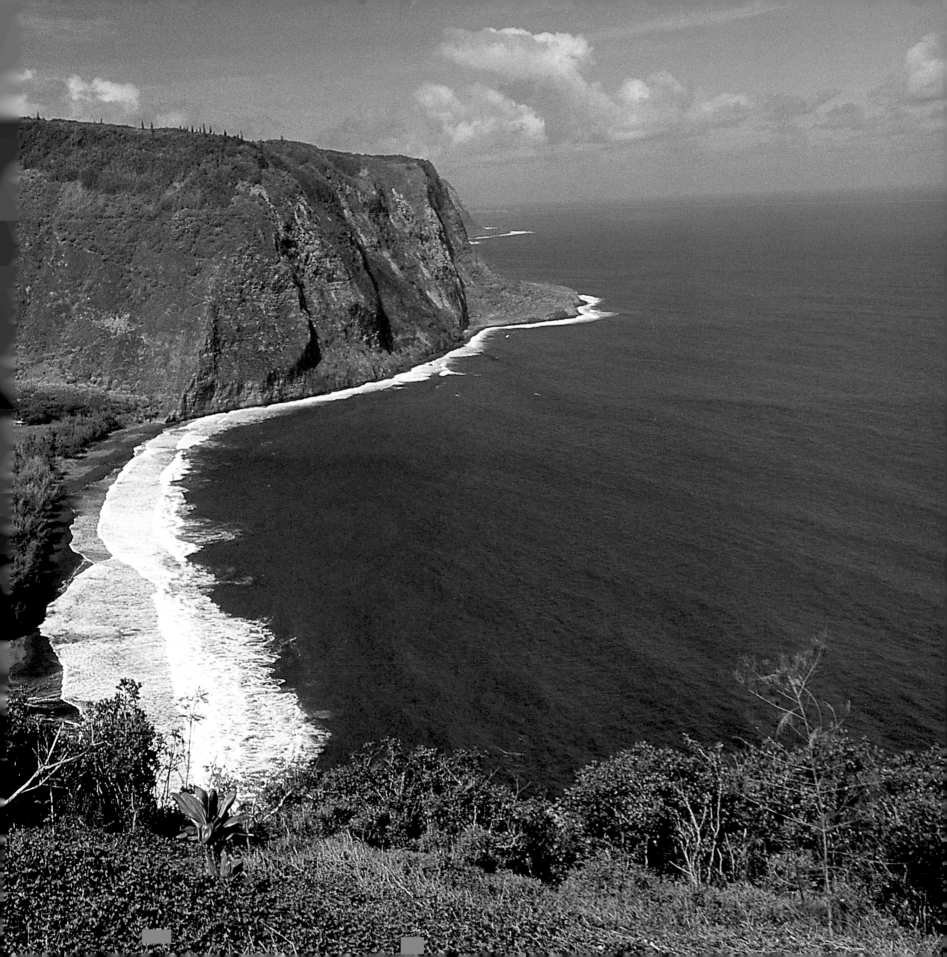

Photo Credits

MICHAEL E. BURCH 1, 3, 10–11, 12, 16, 18, 19, 20–21, 22–23, 24, 32,
35, 65, 80

TERRY DONNELLY 6–7, 8–9, 13, 15, 28, 29, 30–31, 66, 74, 75, 78–79, 82

MICHAEL VENTURA 17, 38–39, 52, 60, 61, 67, 68, 69, 70–71, 72, 76

TOM TILL 26–27, 42–43, 50–51, 53, 54, 55, 56, 62–63, 64, 81, 83, 85

DENNIS JOHNSON/FOLIO, INC. 33

WALTER BIBIKOW/FOLIO, INC. 34, 36–37, 40, 57, 58–59, 88, 92, 94–95

MARK E. GIBSON/UNICORN STOCK PHOTOS 41

BACHMANN/UNICORN STOCK PHOTOS 44, 48

DAVID SCHAEFER/ MACH 2 STOCK EXCHANGE 45

HOWARD L. GARRETT/DEMBINSKY PHOTO ASSOC. 46–47

MARK E. GIBSON/FOLIO, INC. 49

ADAM JONES 73

DARRELL GULIN/DEMBINSKY PHOTO ASSOC. 77

STEPHEN GRAHAM/DEMBINSKY PHOTO ASSOC. 84

POWERSTOCK/MACH 2 STOCK EXCHANGE 86

PHIL DEGGINGER/DEMBINSKY PHOTO ASSOC. 89

JEFF GREENBERG/UNICORN STOCK PHOTOS 90–91